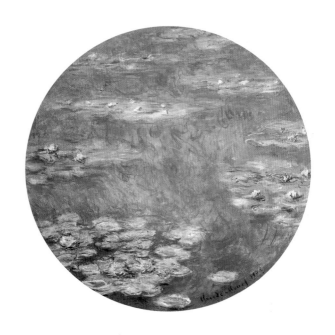

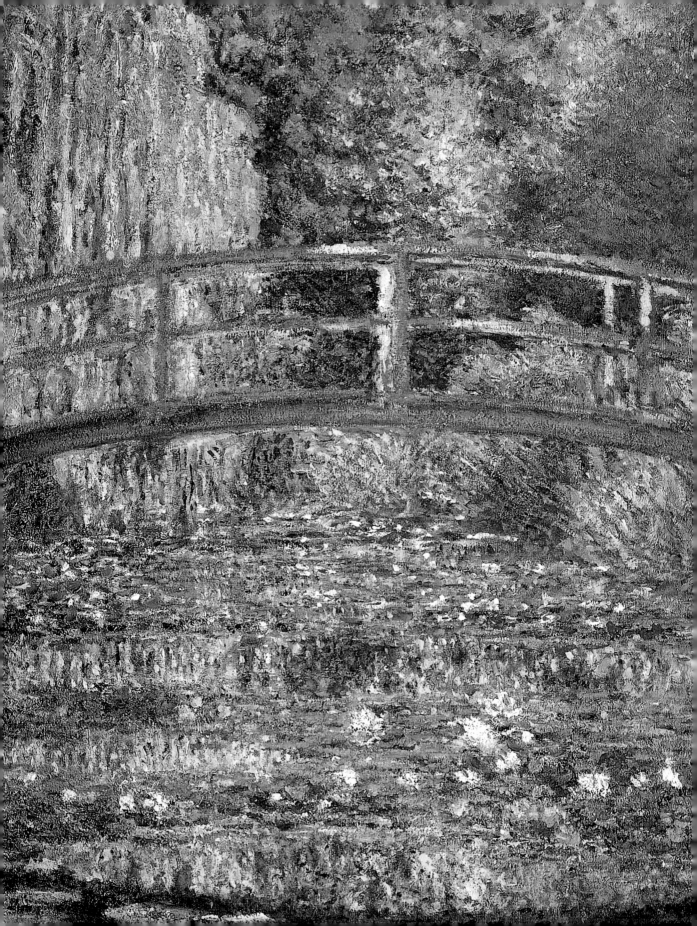

MONET'S GARDEN
in ART

Debra N. Mancoff

F

FRANCES LINCOLN LIMITED
PUBLISHERS

This book is dedicated to my friend Bee Thompson

Frances Lincoln Limited, 74–77 White Lion Street, London N1 9PF
www.franceslincoln.com

Monet's Garden in Art
Copyright © Frances Lincoln Limited 2001
Text copyright © Debra N. Mancoff 2001
Paintings and archive photographs as credited on pages 174–175

First Frances Lincoln edition 2001
First paperback edition 2004
This paperback edition 2015

A catalogue record for this book is available from the British Library.

978-0-7112-3781-0

Printed and bound in China
1 2 3 4 5 6 7 8 9

PAGE 1 *Water Lilies*, 1908
PAGE 2 *Water Lily Pond, Symphony in Green* (detail), 1899

CONTENTS

INTRODUCTION

More than anyone else, Claude Monet recognized that his garden, rather than his words, presented the path to understanding his art. In 1920, to mark the occasion of Monet's eightieth birthday, the Duc du Trevise, a noted collector of Impressionist painting, made a journey to Giverny. He was met at the gate by the elderly master, who, still vigorous, looked like "a poet's vision of old age." Trevise was eager to see the vast studies for the *Grandes Décorations* housed in Monet's studio, but the painter's first words surprised and delighted him. Monet greeted his guest with a simple suggestion: "It's a beautiful day. Shall we take a turn in the garden?"

While Monet was cautious about discussing his art, he was always eager to talk about his garden. His involvement with gardening grew over the years, from the modest flowerbeds that brightened the first house he rented in Argenteuil to the magnificent gardens he cultivated at his home in Giverny. No visit to his home was ever complete without an escorted tour of his two gardens – the colourful flower garden and the tranquil water garden. Critics and colleagues often commented that Monet was a changed man in his garden. The stern manner and the gruff wariness that characterized his public persona in Paris gave way to warmth and ebullience in Giverny. He was always urging his visitors not to miss the ephemeral beauty of his flowers: the blossoming of the iris in the spring, the opening of the aquatic lilies in the afternoon, the blooming of the wisteria as the sun gained strength in the summer. But astute visitors realized that Monet wanted to share more with them than the dazzling seasonal display. The garden offered insight into Monet's art, with a beauty and clarity that he could not put into words.

When Monet did speak about his art, he chose his words with great care. Late in his life, he admitted to one critic, "I have always had a horror of theories," and, when pressed to define his contribution to contemporary

art, he simply stated, "the only merit I have is to have painted directly from nature with the aim of conveying my impressions in front of the most fugitive effects." Throughout his long and productive career, Monet believed that his art served a particular purpose: to give material form to the expression of his feelings in front of the visual spectacle of nature.

Inspired by his two intertwined passions – nature and art – Monet relied upon his powers of observation and allowed his eye to guide his brush. From his earliest experiments in *plein-air* painting which established his reputation as an Impressionist to his culminating ensemble, the *Grandes Décorations,* Monet sought to capture the dynamic effects of sunlight and atmosphere on a static canvas. In charting a world of change – the daily cycle of the sun and yearly sequence of the seasons – Monet transformed the temporal into the timeless, finding in a moment's glance an infinite range of expression.

Born in Paris on 14 November 1840, Oscar-Claude Monet spent most of his youth in Ingouville, a small suburb north of the port of Le Havre on the Normandy coast. His upbringing was modest; the nature of his father's business is not recorded, but his family found it necessary to take in boarders to supplement their income.

Young Monet received his education at the local school in Le Havre, where he studied art with the drawing master Jacques François Ochard. None of his early works have survived, but in later life Monet recalled that he drew constantly, embellishing his schoolbooks with caricatures and designs. His first surviving sketchbooks reveal a precocious talent and an interest in natural subjects. These included picturesque scenes of the countryside around Le Havre, studies of plants and rock formations, as well as sketches of ships and the local residents. Around 1858, Monet was introduced to the marine painter Eugène Boudin, who encouraged him to work in a spontaneous manner, painting on the spot in the open air, to develop his sensitivity to the appearance of his subjects in natural light. Looking back at his youthful endeavours, Monet recalled that by working with Boudin, "my eyes were finally opened and I really understood nature."

EARLY EXPERIENCE

In the spring of 1859, Monet travelled to Paris to further his education as a painter. Arriving in mid-May, he attended the annual exhibition of the Salon, the official display of contemporary work associated with the Ecole des Beaux-Arts. There he admired the works of the landscape

Pierre August Renoir, *Monet Painting in his Garden at Argenteuil,* 1873, Wadsworth Atheneum, Hartford, Connecticut. As a young artist in Paris, Monet gained a reputation as a painter of the urban landscape. But, in 1872, the first summer he lived in Argenteuil, he discovered a more sympathetic environment: the beauty of his own garden. For the rest of his career, Monet would turn to his garden for solace and inspiration.

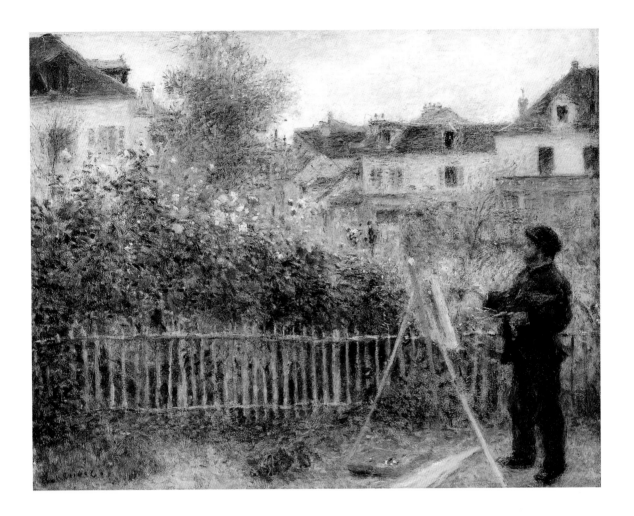

painters Constant Troyon, Camille Corot, and Charles-François Daubigny. All belonged to the Barbizon School, a group of artists named after the small village on the outskirts of the forest of Fontainebleau where they lived and worked. These artists shared with Boudin a naturalistic approach to the landscape, an appreciation of the subtle effects of light, and a dedication to painting out of doors, or *en plein air.*

Monet enrolled at the Académie Suisse, an independent atelier run by a former model. Unconnected with the official programme at the Ecole des Beaux-Arts, the Académie Suisse neither charged tuition nor followed a strict curriculum. Instead, each artist paid a small fee which secured a shared studio space, an opportunity to draw from a live model, and the chance to critique each other's work. Monet quickly became friends with Camille Pissarro, a like-minded member of the atelier, who joined him on painting expeditions in the countryside around Paris.

Monet's studies in Paris were interrupted in the spring of 1861 when he was conscripted into the army. He joined a division of the cavalry, the Zouaves, and was shipped out to Algiers. Long before completing his five-year term, he contracted typhoid fever and, in August 1862, he returned to his home near Le Havre. But when he recovered, he had no desire to rejoin his regiment, and, with the generous support of his paternal aunt, Sophie Lecadre, he was able to buy his way out of the army and resume his art training in Paris. To oblige his "Aunt Lecadre" and his father, who worried about his future prospects, Monet agreed to enrol in a more traditional atelier, and late in 1862, he entered the studio of the Neo-Greco painter Charles Gleyre. A tolerant teacher, Gleyre encouraged his students to follow their own pursuits, and with fellow students Frédéric Bazille, Pierre Auguste Renoir, and Alfred Sisley, Monet divided his time between figure work in the studio and landscape painting in the open air.

Monet and his friends became fascinated with contemporary urban subjects. When they painted in the outskirts of Paris, they included the railway trestles and the factories with their smokestacks, providing a realistic account of modern expansion and the industry that encroached upon the countryside. They set up their easels in public parks and on balconies overlooking the city streets to capture the essence of urban life. They shared a desire to capture the image of the moment, an idea that would unify the diverse styles of the artists of the first Impressionist circle a decade later. Late in 1864, failing vision and poor finances forced Gleyre to close his atelier, and Monet ended his formal training.

In the following spring, Monet submitted two large seascapes to the annual Salon which were accepted for exhibition. He exhibited another seascape in 1866, but in 1867, his work, along with that of Bazille, Pissarro, Renoir, and Sisley, was rejected. Monet tried again in 1868, succeeding with another seascape. But his rejected work of the previous year, *Women in the Garden* (see page 16) caught the discerning eye of aspiring novelist Émile Zola, who was writing art criticism at that time. He praised Monet and his colleagues for painting life precisely as they saw it rather than according to conventional ideals. Impressed with Monet's acuity of observation, Zola expressed his admiration for the painter's "special affection for nature that the human hand has dressed in a modern style," calling upon the jury to recognize the rightful place of modern life subjects in contemporary art. But repeated rejections in subsequent years prompted Monet and his colleagues to abandon the official Salon and pursue independent venues for exhibition. Near the end of his life,

when Monet was nominated for membership of the prestigious Institut de France, he refused the honour, declaring, "I have always been, I am, and always shall be independent."

Monet's interest in painting gardens emerged in tandem with his focus on contemporary life. The manicured gardens of the Tuileries in Paris and the formal plantings of the terraces of the Normandy resort town of Sainte-Adresse, where he visited his aunt, provided a refined setting for his modern subjects, which often featured men and women in fashionable attire. In these portraits of urban elegance Zola saw evidence of a painter who possessed "an exact and candid eye" and sought a "point of view in the world he inhabits." But in 1871, Monet made a decision to change the world he inhabited and moved out of Paris into the suburb of Argenteuil. There he found a serene working environment and contentment with his family life. And there Monet first tended his own garden. The house he rented was surrounded with flowering bushes. The terrace in the back featured colourful beds, to which Monet added planters spilling over with flowers. He painted his first wife and their son outside their home, and the garden, once the context of his urbanity, became the setting in which he was able to express an intimate appreciation for comfortable domesticity. Years later, Monet would also recall that the garden soothed him during difficult times; it became a refuge where tending his plants and working at his easel merged his love of nature and art.

THE MOVE TO GIVERNY

In 1883, Monet moved to Giverny. He remained there for the rest of his life, and in the course of more than forty years, he transformed the land that surrounded his home into a garden that reflected his own vision of domesticated nature. Nestled in the valley of the Seine, between rising cliffs and flowering meadows, the region provided an extraordinary range of varied terrain and atmospheric effects. The morning mists, the gentle rains, the warm sun, and the long growing season provided an ideal climate for cultivating a garden where Monet could always find a suitable subject to paint.

The garden became an extension of his artistic creation. At first, he tended it with the help of his children, but as it grew in scale and scope, he hired a staff of professional gardeners to work under his direction. Monet read the latest books on horticulture and, like other avid gardeners of his generation, he ordered seeds and bulbs from plant catalogues that featured varieties of flowers and plants from every corner of the world. In 1893,

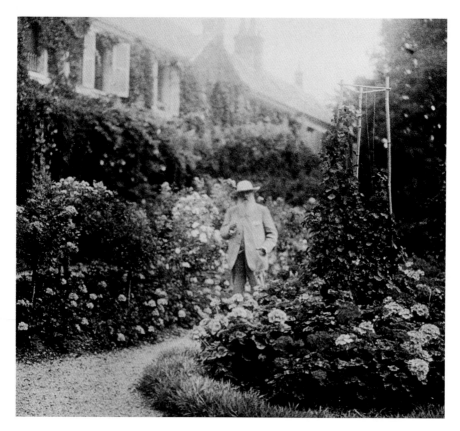

Monet in his Garden at Giverny, c. 1924, private collection.

Monet first planted his flower garden at Giverny with modest expectations: "I should like to grow some flowers in order to be able to paint in bad weather." As the years passed the garden flourished, with its densely planted beds arranged according to colour, like pigments on a palette. As a testament to his dual passion for art and nature, Monet recognized the deep, reciprocal relationship between his painting and his garden.

he purchased an additional plot of land across the road that fronted his property and there he created his water garden, a tranquil pool covered with aquatic lilies and surrounded with willows, bamboo, and flowers which thrived on the marshy banks.

Through the cultivation of his garden, Monet advanced his art. During his early years at Giverny, he travelled extensively – to the Normandy coast, to Rouen, to the Riviera – seeking sites where he could observe the temporal and seasonal changes of light over the course of time at a single location and capture the fleeting transformations on his canvas. But as his garden grew to maturity, he found what he sought at home. He arranged the beds of his flower garden like a grand-scale, living still life, grouping his plants according to colour and height, then allowing nature to bring them into their full beauty. When he painted the flowers, he saw fields of fresh colour that he portrayed in pure pigment, observing the hues of nature under the intensity of natural light. The water garden was designed as a lush enclave of grasses, trees, and flowers, with undulating banks and winding paths. Every morning a gardener would thin out the

Henri Manuel, *Monet in his Studio at Giverny*, private collection. Monet described his water garden in the simplest words: "I have always loved sky and water, leaves and flowers. I found them in abundance in my little pool." Countless hours of quiet contemplation, watching the bright lilies gliding on the glassy surface of the waters, led Monet to the most daring innovations in his painting and the most enduring motif in his art. "It took me a long time to understand my water lilies," he confessed. "And then all of a sudden, I had the revelation of the enchantment of my pond. I took up my palette."

lilies to open the surface of the pond to accidents of reflection and then rinse the remaining pods of accumulated dust and arrange them in loose circles. There, Monet watched and painted as the random flow of the water scattered the lilies over the water's glassy surface, dappled with reflections of the overhanging trees and the clouds that floated above in the sky. French novelist, Marcel Proust, who never saw the gardens, imagined them as a "living sketch . . . like the palette already artfully made up with the harmonious tones required to paint it." In pursuit of his art, Monet entered into a deeply personal communion with nature, creating his garden as a departure point for infinite natural effects, which he could observe and paint as they unfolded before him.

During the late, productive decades of his life, Monet sought his sole inspiration in his garden. He submitted his art to the cycle of the seasons, waiting in anticipation for spring as the first of the flowers came into bloom, working to exhaustion through the summer, and relying upon his memory of the visual sensations he gathered to perfect his studies in the studio through the winter.

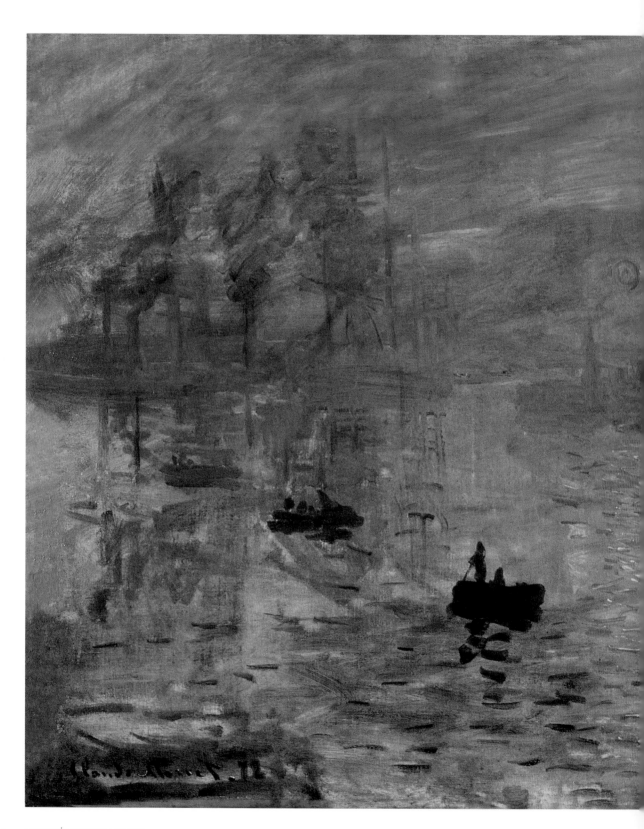

Astute critics recognized that Monet's endeavours as a gardener were an essential part of his identity as a painter and that his artistic vision drew strength from his passion for his garden. But he bristled when the same critics described his paintings as depicting a "fairyland," a realm of enchanted beauty separate from any conceivable reality. He countered that painting his garden was "an act of faith, an act of love and humility," in which he struck a harmony with nature that allowed him "to identify with creation and become absorbed in it." He could not imagine a subject more strongly rooted in what was real, for he held the conviction that, "When one is on a plane of harmonious phenomena, one cannot be far from reality, or at least what we can know of reality."

Impression: Sunrise, 1872, Musée Marmottan–Monet, Paris.
Monet's evocation of the sun rising through the mist over still, gleaming water drew derision from the critics at the first exhibition of the "Société anonyme" (later known as the "Impressionists"). His loose, but descriptive brush work came under particular fire, dismissed as unfinished and undisciplined. But the short brush strokes that became a stylistic hallmark of Impressionism capture the transitory nature of a specific, atmospheric experience.

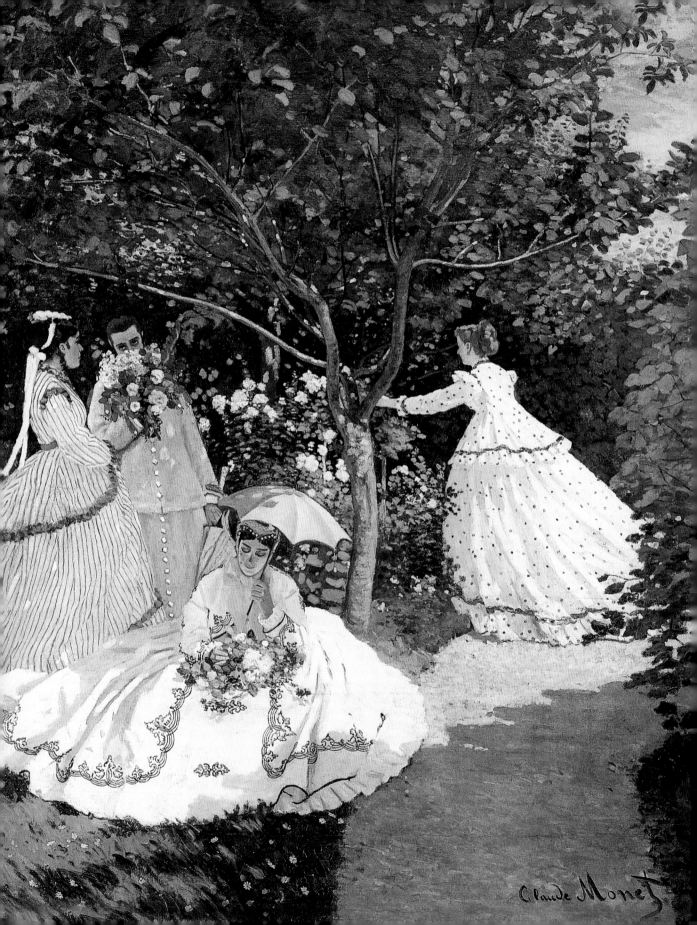

Chapter 1
HOME AND GARDEN

Women in the Garden,
1866–1867, Musée
d'Orsay, Paris.
The sunlight streaming
through the branches
of the trees and the
irregular dappling of
light on the ground and
on the women's dresses
reveal Monet's close
observation of the effects
of natural light. His
subject – elegant women
in fashionable attire – led
Zola to hail him as a "true
Parisian." Although this
composition was begun
in a garden attached to a
house that Monet briefly
rented, the urbane spirit
suggests that the setting is
a public park.

Claude Monet rose to critical attention as a painter of the modern urban scene. In 1868, in an article published in the popular newspaper *L'Evénement,* novelist and art critic Émile Zola hailed him as the leader of a new group of artists he called *"Les Actualistes."* According to Zola, these daring young painters portrayed the world precisely as they saw it, using their art to express the spirit of contemporary life with the force and vitality of actual experience. Among them, Zola singled out Monet for particular praise, exclaiming, "Here is a man who has nursed at the breast of our times, who has grown up and will grow still more in his affection for his surroundings."

Zola's observations proved true. In the course of his long and productive career, Monet remained deeply engaged and inspired by the world that surrounded him. But, a few years after Zola's article appeared in the press, Monet left Paris, seeking a tranquil retreat for his family and his work. Throughout the years of the 1870s, a decade of change and challenge for Monet, he drew strength from the domestic security of suburban living. The houses he chose to rent during those tumultuous years were all large and comfortable, located within easy access of the rail line to Paris and close to the River Seine. And each house had a garden, where the beauty of blooming flowers and lush trees were always there to inspire him. Late in life, Monet poignantly recalled his affection for those gardens, stating: "Gardening was something I learned in my youth when I was unhappy. I perhaps owe having become a painter to flowers." Away from the city, Monet discovered the subject that would prove to be his life-long inspiration; those modest, suburban gardens provided Monet with a cultivated, but natural setting in which he could strike the delicate but necessary balance between life, work, and art.

UNCERTAIN TIMES

Despite Zola's confident predictions, during the early years of the 1870s Monet faced professional uncertainty. In 1868, the official Salon had accepted only one of his paintings for exhibition, and in the following two years, his submissions were rejected. The outbreak of the Franco-Prussian War in July 1870 prompted Monet to leave Paris. Nine years earlier, in 1861, he had been drafted into the French Army. After only six months' service, he took convalescent leave and never returned to his regiment. Now, as the new conflict escalated, Monet feared conscription. On 5 September 1870, Monet secured a passport, and shortly after, he left for London.

Although Monet did not produce many paintings during the eight months he remained in London, his stay there had a powerful influence on his career. In the company of his friend and fellow artist Camille Pissarro, he studied the landscapes of John Constable and J.M.W. Turner, artists who shared his conviction that natural observation was essential to aesthetic expression. Monet also met Paul Durand-Ruel in London. A French dealer with international clients, Durand-Ruel arranged for the exhibition of Monet's work in London and, with only a few, brief interruptions, Durand-Ruel's firm continued to represent Monet until his death. Monet remained abroad until long after the conflict at home ended in the last days of January in 1871, travelling to Holland that May for an extended sojourn. In the autumn he returned to Paris.

The first years of the decade also brought significant changes to Monet's personal life. On 28 June 1870, he married Camille-Léonie Doncieux. A native of Lyons, but raised in Paris, Camille appeared as a fashionably dressed model in Monet's paintings as early as 1865. Their first son Jean had been born on 8 August 1867, but they had not wed at that time, due to objections from Monet's family and financial constraints. Their pleasure in their long-delayed marriage was soon blunted, however, when barely a week later Monet's aunt Sophie Lecadre died. "Aunt Lecadre" had been a staunch supporter of Monet's aspirations, giving him both monetary support and enthusiastic encouragement. Other personal losses followed: Monet's close friend the painter Frédéric Bazille was killed in action in November, and, early in the new year, his father Claude-Adolphe died.

On his return to Paris in the autumn of 1871, Monet observed with distress the damage to the city caused by the Prussian siege and the subsequent insurrection of the Commune. Many of the trees planted along the new boulevards during the reign of Napoleon III, as well as older growth in the Bois de Boulogne, had been chopped down or burned, and

the streets and the public parks still bore the scars of armed conflict. Monet yearned for a more congenial setting in which to live with his family and pursue his art, and in December 1871, he rented a house in the village of Argenteuil.

Argenteuil lay on the right bank of the River Seine, only about seventeen miles by water northwest of Paris. During the nineteenth century, Argenteuil had become a popular weekend retreat for middle-class Parisians, offering a picturesque landscape, pleasure boating, and the pace of country life in a modern suburban setting. The author G. Lafosse characterized the town in his 1850 publication *Histoire des environs de Paris* as "a cheerful village . . . full of life and rich features." As well as an idyllic atmosphere and delightful vistas, Argenteuil offered convenient access to Paris. The little town described in contemporary guidebooks as a *"petite ville agréable,"* was situated on the rail line; a fifteen-minute journey sped a passenger from Argenteuil to the Gare Saint-Lazare in Paris.

A QUIET RETREAT

Even before the disruption of the Franco-Prussian War, Monet longed for a quiet and natural environment to follow his artistic vision. While on a painting trip to Normandy in December 1868, Monet wrote to Bazille that he did not miss the bustle of the city, confessing that "my desire would be to remain forever in a nice quiet corner of nature like this one." Argenteuil offered Monet an agreeable compromise between the city and the country: a quiet retreat with close proximity to Paris. The house Monet chose to rent was close to the train station, as well as to the Seine. He settled his family in their new home in the early months of 1872, and in the magnificent spring that followed, the beauty of the blooming garden and the surrounding orchard provided inspiration for his art just steps outside his door.

Monet selected a stand of blooming lilacs as the setting for the first garden pictures he painted in Argenteuil. These four paintings, *The Garden, Lilacs in the Sun, The Reader,* and *Lilacs, Grey Weather,* feature fashionably dressed women relaxing in the shade of the spreading branches. But the true subject of these paintings is the quality of light and the effect of atmosphere. Using a shimmering palette to suggest the delicate tints of spring flowers and short, swift brush strokes to evoke the volatile quality of the sunlight breaking through the branches and dappling the ground in a pattern of light and shade, Monet recorded his observations of the figures in a natural setting bathed in light.

Just four years earlier, Zola declared that, as a "true Parisian," Monet infused his landscapes with an urbane spirit, always including men and women dressed in the latest fashion. Whether he set his works in city parks or rural retreats, Monet displayed a marked preference for a cultivated garden over a natural forest, prompting the critic to assert that, "Nature seems to lose its interest for him as soon as it no longer bears the stamp of our mores." As an example, Zola described Monet's painting *Women in the Garden* (see page 16)*,* which featured four women in flowing summer gowns "in a garden plot well-groomed by a gardener's rake." The setting for the painting was a garden attached to a house that Monet had rented outside Paris in Ville d'Avray in the summer of 1866, but it was completed in his studio the following winter. The elegant dress of the women – as well as their self-absorbed actions – dominated Monet's interest in this composition. In painting the stands of lilacs in Argenteuil four years later, Monet emphasized the garden setting over its inhabitants, suggesting that, as Émile Zola had predicted, he had indeed grown in his "affection for his surroundings."

But there is an impersonal objectivity in Monet's first depictions of his garden in Argenteuil. In three of the four canvases, Monet positioned his easel at some distance from the stand of lilacs, rendering the figures as anonymous and the setting as unidentifiable. It could easily be a public park, for there is no evidence of his home or of its suburban setting. Even a more personal subject, a charming portrayal of his son Jean on a horse tricycle painted later that summer, offers little suggestion of a specific location. Rather, these images convey the sense of a private haven in a public space. Throughout his first year in his new home, Monet was exploring the pictorial possibilities of Argenteuil. He painted the fields surrounding the town, the streets of the village, and the views from the Seine on his studio boat – a small craft equipped with a cabin for shade where he could paint – as well as the scenes in his garden.

LIFE AT ARGENTEUIL

The garden paintings of the summer of 1873 provide a more intimate glimpse into Monet's life at Argenteuil. *The Artist's House at Argenteuil* presents the setting just outside his door. Delineated by trees in full foliage on the left and the façade of the house on the right, Monet presented his family's garden retreat. In the centre of the composition, Jean stands with his back to the viewer, engrossed in play with his hoop. Camille is seen coming out of the door at the top of the stairs dressed in a stylish gown

The Artist's House at Argenteuil, 1873, The Art Institute of Chicago. During his first years in his home in Argenteuil, Monet struck a fine balance between inspired productivity and domestic tranquility. His garden proved a source of continuing inspiration. Here, with Jean on the terrace and Camille peeking out the door, Monet portrays the effect of the bright summer sun on the vivid red flowers and cool shade trees that line the edge of his garden (see detail bottom right). The scene also offers a glimpse of the pleasure he took in his family.

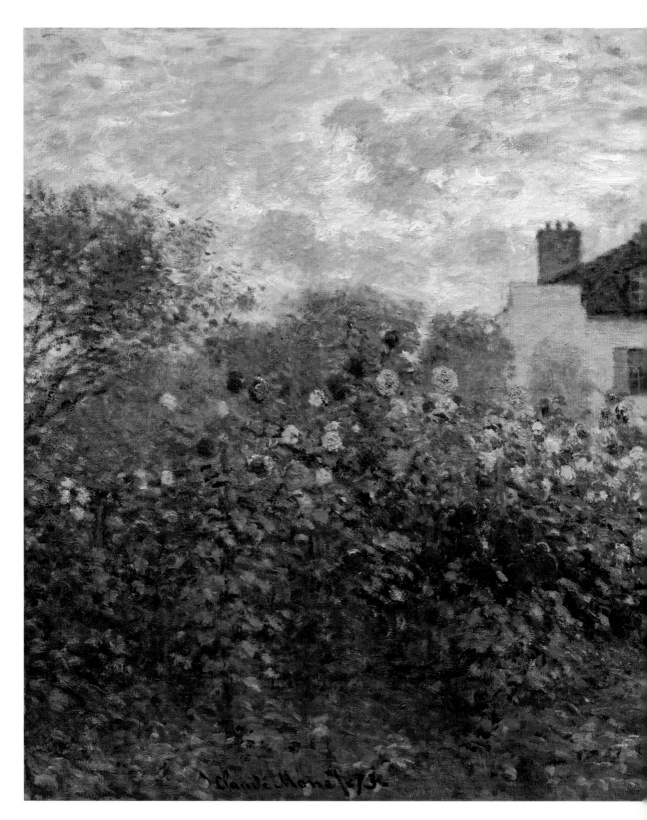

MONET'S GARDEN IN ART

The Artist's Garden in Argenteuil (a Corner of the Garden with Dahlias), 1873, National Gallery of Art, Washington D.C.

The spectacle of dahlias in full bloom, ranging in tones from deep red to pale yellow, seen against the muted foliage of the trees, suggests the heavy atmosphere of summer. In reality, the house that anchors this composition was surrounded by similar ones (see page 9), but Monet simply left them out, enhancing the impression that his home in Argenteuil was a secluded haven of serenity.

and a broad-brimmed, elegant hat. Banks of red flowers run along the base of the house, which is covered with climbing ivy, and lush, well-tended plants in blue and white urns line the terrace where Jean is playing. The composition is informal, but it also offers a wealth of material display – a fine house, a well-dressed family, and a beautifully cultivated garden – that characterizes Monet's appreciation for his life in Argenteuil. Private and pleasing in its comfort and domestic security, Monet presented his garden as a place apart from the world. In *The Artist's House at Argenteuil* Monet's characteristic objectivity diminished, allowing the artist to express a more personal response to the setting in which he lived his life. Even his point of view – neither distant from nor above his subject, but on the same plane as if his presence as part of the family is meant to be implied – established a stronger bond between the artist and his subject than he previously attained. For Monet, the garden had become a personal sanctuary, a natural setting for the convergence of his art and his life.

In *The Luncheon* Monet depicted one of the pleasures of a life of genteel prosperity. The subject is a midday meal on a summer's day, enjoyed in the garden under the shade of the trees and surrounded by the rose bushes in full flower. The rumpled table cloth,

The Luncheon, 1873, Musée d'Orsay, Paris.
With a wealth of closely observed details Monet describes the intimate informality of his life in Argenteuil: a sip of wine remains in a glass, a hat dangles from a branch, a parasol lies abandoned on a bench. He also conveys the pleasant sensations of a summer afternoon: hot sun, cool shade, and even the rose-scented air, invoked by the brightness of the blooms.

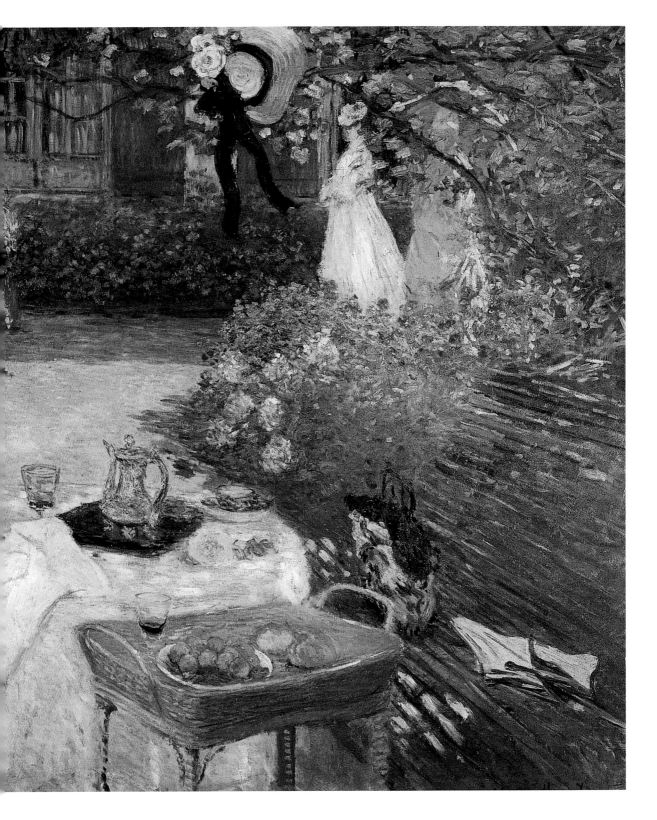

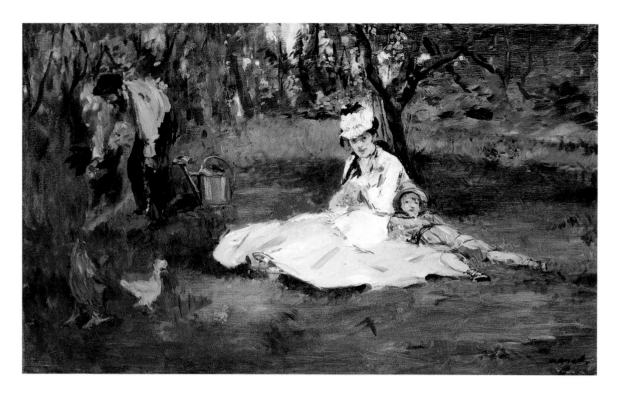

scattered cups and saucers, as well as the remnants of a simple repast of bread, fruit, and cheese, reveal that the meal has concluded. Camille and an unidentified woman stroll by the flowerbeds near the house, while Jean plays with his blocks in the cool shadow of the trees that shade the table. The roses are in full bloom, bright and red in the midday sun. Although set out of doors, the scene conveys the intimacy of an interior setting, reminiscent of the family meal Monet depicted several years earlier in *The Luncheon, Etretat.* In its celebration of domestic pleasure, *The Luncheon* also suggests the influence on Monet of Dutch scenes of middle-class life. But the garden setting evokes the protected world seen in the eighteenth-century French garden pictures, where a shady bower provides an intimate haven safe from any public intrusion.

The rich beauty of Monet's garden in Argenteuil is captured in another painting of the summer of 1873, *The Artist's Garden in Argenteuil* (see pages 22–23). To attain the wide vista, encompassing the house, some of the surrounding trees, and a magnificent expanse of dahlias in full bloom, Monet positioned his easel at some distance and slightly below his subject. Although the elegantly attired couple, portrayed near the fence in front of the house, recalls the urbane figures in his earlier depictions of city gardens, the atmosphere of this painting evokes the quiet seclusion that Monet saw

Édouard Manet, *The Monet Family in their Garden at Argenteuil*, 1874, The Metropolitan Museum of Art, New York. The vitality of Monet's landscape painting convinced Manet of the value of painting out of doors. In the summer of 1874, Manet and Renoir visited the Monet family and painted them in the garden. Sun and shadow play on Camille's brilliant white gown, but Monet is seen in the shade, working on his garden. At Argenteuil, Monet employed a gardener, but he also enjoyed tending his garden himself.

as essential to his new domestic life. No other figures disturb the tranquillity of his garden, and from this prospect, his house appears to embody the spirit of the *"petite ville agréable"* that made Argenteuil such a popular weekend retreat for Parisians.

But throughout the 1870s, Argenteuil was changing. Growing industry and easy rail access lead to rapid modernization and a dramatic expansion of the population. When Pierre Auguste Renoir visited his friend Monet in Argenteuil in the summer of 1873, he portrayed Monet painting in his garden (see page 9*)*. Renoir observed the same vista that Monet used in *The Artist's Garden in Argenteuil* (see pages 22–23), but he showed the setting as he saw it, with a crowd of houses blocking the view to the right. While Monet never hesitated to include the evidence of growing industry – the factories, smokestacks, and loading docks along the Seine – in his landscapes of the village of Argenteuil and its surroundings, he idealized his own home as separate from the suburban sprawl, a haven of domestic peace and tranquility.

Monet enjoyed the solace of his suburban home, but he also maintained strong links to the art world based in the city. He made regular trips into Paris to meet with his dealer Durand-Ruel, and he stayed in close contact with his circle of like-minded painters. Édouard Manet and Gustave Caillebotte had summer residences in nearby Petit-Gennevilliers, and Monet invited others, such as Renoir and Alfred Sisley, to escape the city and join him in Argenteuil to paint. As early as the spring of 1873, Monet and his colleagues, including Pissarro, Renoir, Sisley, and Paul Cézanne, began to explore the possibility of developing an alternative venue to the official Salon for the exhibition of their paintings. Discontented with the restrictive policies of the Salon jury – and frustrated by repeated rejections – they joined forces to mount an independent endeavour.

BIRTH OF THE IMPRESSIONISTS

On 15 April 1874, the first exhibition of the *"Société anonyme des artistes peinteurs, sculptures, graveurs"* was held in the studio of photographer Félix Tournachon, known as "Nadar." It ran for a month, and the radical style of painting, featuring *plein-air* landscapes and modern life subjects, attracted as much notoriety as critical acclaim. In a satirical review for the popular paper *Le Charivari*, critic Louis Leroy mocked the title of Monet's *Impression: Sunrise* (see pages 14–15), writing, "Impression – I knew it. I was just saying to myself, if I'm impressed, there must be an impression in there." Although meant to be derisive, Leroy's comment gave the group its

name, and over the course of the next eleven years, the "Impressionists" organized seven more exhibitions, the final one held in 1886.

On a sunny summer day in 1874, Renoir and Manet set up their easels side by side to paint in Monet's garden. Renoir concentrated on Camille and Jean, in *Camille and her Son in the Garden at Argenteuil,* but Manet included the artist with his family. As in Renoir's portrait, Manet presented Camille in her stylish summer gown, seated on the lawn, with Jean sprawled next to her. Monet is seen at the left, engrossed in tending his flowers, with a watering can at his side. It is a picture of domestic leisure, a happy idyll of the ease and comfort of suburban life. But, by this time, Monet had fallen behind in his rent and had been served a notice of impending eviction.

Financial problems had plagued Monet throughout his early career, and he often turned to family and friends for loans to see him through the difficult times. Sales of his paintings had, in fact, brought in a secure income during his first years in Argenteuil, but he had an inclination to live beyond his means. Both he and Camille liked to dress well and in the latest fashions. He was a generous host and offered his guests ample meals and fine wines. To help Camille run the household, he employed two servants and a nanny, as well as a professional gardener who worked under his direction. Monet depended upon Durand-Ruel to purchase his works for sales, but in the spring of 1874, when the dealer faced his own financial difficulties, Monet found himself short of ready cash.

With Manet's assistance, Monet located another house to rent in Argenteuil. By 18 June, he secured a lease for a bungalow with a garden surrounded by an orchard that would be ready for occupation in October. The new home, which Monet described in a letter as a "pink house with green shutters," was, in fact, more costly to rent than his first residence; Monet was confident that he could make up the difference with sales of his work. But in December, the *Société anonyme* was dissolved in bankruptcy, and the auction the members held in the following March to recuperate their losses brought disappointing results. That summer, Monet again turned to his garden for inspiration, painting Camille sitting among the flowerbeds and strolling under the trees. In 1876, Camille posed for several pictures in the garden, wearing a pale lavender gown. Her presence is ghostly; she appears as a wisp of icy colour behind the tall gladioli – bright in hue – that gleam with vitality in the sun. The aura of domestic satisfaction that graced the earlier garden paintings is noticeably absent; the beauty of the garden has endured, but the sense of the comforting life lived there has become elusive.

Portrait of Alice Monet aged 35, Musée
Marmottan-Monet, Paris.
Monet met Alice Raingo Hoschedé during the
summer of 1876, when he was completing a
commission from her husband. The two families
drew close, and when Hoschedé became bankrupt,
Alice turned to Monet for help. She, in turn,
tended his first wife Camille through the course
of her fatal illness. After Camille's death, Alice
remained with Monet. Devoted companions, they
married in 1892, after her first husband's death.

In the summer of 1876, Monet travelled to
Montgeron, about four miles from Argenteuil,
to fulfill a commission of four decorative panels
for the department store owner Ernest Hoschedé.
Monet spent several months at Hoschedé's
elegant home, the Château de Rottenbourg.
He selected traditional subjects for the panels:
garden vistas, a hunting scene, and a painting of
turkeys. Away from the pressure of his financial
worries, Monet enjoyed Hoschedé's generous
hospitality, as well as the company of his wife
Alice and their six children. Early in the new
year, Monet took up temporary residence in
Paris, in a small apartment rented for him by
his friend Caillebotte and spent the next three
months working on his first series of paintings,
the trains at the Gare Saint-Lazare. In April
1877, he exhibited a selection of these works at
the third Impressionist Exhibition, reasserting
his reputation as a painter of modern city life.

Later that year, Hoschedé's extravagant life-
style led him to declare bankruptcy. With the
fall of his new patron, Monet's income was
depleted, and his situation was further strained
when Camille's health began to fail. He painted
little during the later months of 1877, and by
the end of the year, with the help of Manet
and Caillebotte, he moved his family back to
Paris. With his finances in ruins, his domestic
life was fraught with difficulty. On 17 March
1878, his second son Michel was born. The
birth exacerbated Camille's fragile state, and her
condition became dire. She was soon confined
to bed. Although Monet had recognized that
the domestic idyll he had enjoyed in Argenteuil
had irrevocably ended, he yearned to find
another locale where life and work converged
in harmony.

NEW SURROUNDINGS

On 1 September 1878, Monet shared the good news with Eugène Murer, one of his patrons, that he had once again moved out of the city: "I have planted my tent," he wrote, "in a ravishing spot on the banks of the Seine at Vétheuil." Vétheuil was a quiet village, located nearly forty miles north of Paris. It had not experienced the boom in population or the growth of industry that had turned Argenteuil from a picturesque village into a modern suburb. Monet rented a house on the southern edge of the town near the banks of the Seine. He began to work with renewed energy, painting views of the river and the surrounding countryside. Although the setting was now conducive to life and work, new difficulties arose, when Hoschedé, in desperate straits, turned to Monet for help. Shortly after Monet settled his family in Vétheuil, Hoschedé, Alice, their six children, and their servants all joined them there, crowding the household and straining Monet's meagre resources. But Alice's presence proved to be invaluable as Camille's health declined. When Camille died on 5 September 1879, Alice gave Monet the practical and emotional support he needed, and, in the following months, she remained with him when her husband returned to Paris to attempt to recover his losses.

With Alice running the household, Monet now presided over an extended family. By the end of 1881, Monet realized that he could no longer maintain the house in Vétheuil. With Zola's advice and assistance, Monet chose to move to a less expensive home in Poissy, a small town on the left bank of the Seine on the outskirts of the western suburbs of Paris. Despite her husband's protestations, Alice joined Monet there with all the children, and she remained with him for the rest of her life.

Before he moved his household in the summer of 1881, Monet painted his youngest son, Michel with Jean-Pierre Hoschedé in the garden (see pages 32–33). The little boys stand on the flower-lined path to the house, dressed in their summer whites. They seem to be smaller than life, diminished by the towering sunflowers flanking the path and the steep staircase which rises behind them. But unlike Camille's ghostly presence in the pictures he painted that last summer in Argenteuil, the boys seem to be part of the environment, rather than an apparition of times passed. Monet was painfully aware that the pleasures of his life in Vétheuil were transitory. After he left his modest home in Vétheuil for the less congenial surroundings of Poissy, he would long to recover a sympathetic affection for his surroundings, in his own home and his own garden.

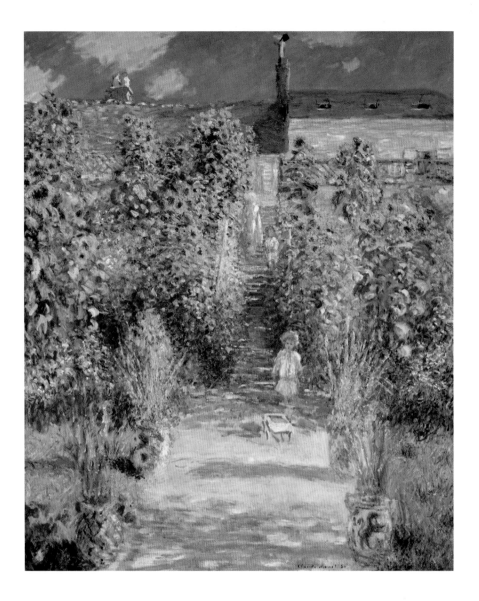

The Artist's Garden at Vétheuil, 1880, National Gallery of Art, Washington D.C.
The picturesque village of Vétheuil was home to the Monet family for a few
years. During the summer of 1881, Monet painted the towering sunflowers that
flanked the garden path several times to observe the changing light. Here, Michel
Monet and Jean-Pierre Hoschedé are seen between the lofty stalks (see detail
right), but Monet concentrates on the colour sensations, with the boys becoming
an incidental feature of the composition.

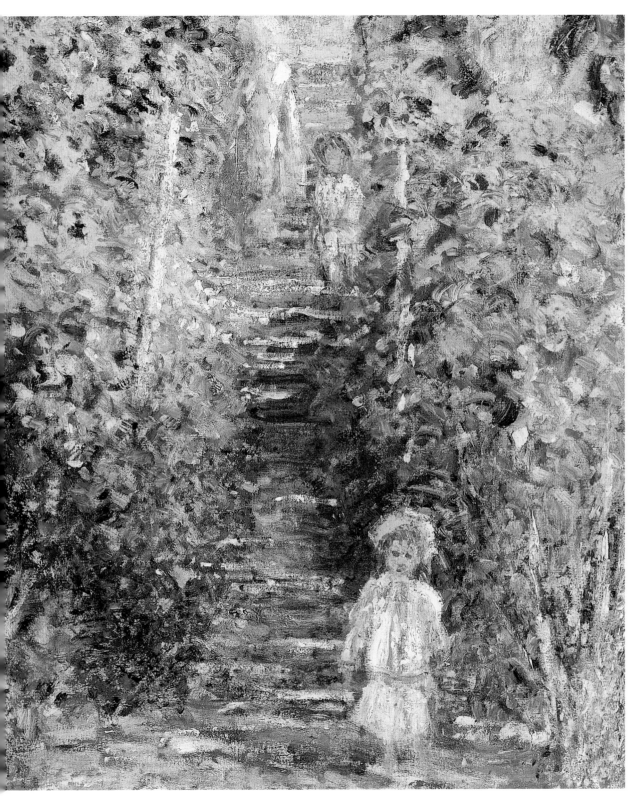

Chapter 2
NEW ROOTS AT GIVERNY

Monet never felt at home in Poissy. He had chosen the crowded suburb for its proximity to Paris in hopes that his increased presence and participation in the art world would advance his career. Poissy also offered better educational opportunities for his children than Vétheuil. But the area was heavily industrialized and densely populated, and Monet quickly found his surroundings claustrophobic. Within two months of settling his family in their new home, Monet began to travel, seeking subjects to paint, for there was nothing in Poissy that inspired his imagination.

His financial circumstances remained dire. Monet depended upon Durand-Ruel to cover the expenses of his painting trips, but, in February 1882, one of the dealer's main backers went bankrupt, forcing Durand-Ruel briefly to suspend his generous support. Strapped for money to provide for his family and allow him to continue to produce saleable paintings – his only means of income – Monet cut his household budget to the bone, but he still fell into arrears on the rent. In the spring of 1883, as the lease on the house in Poissy was about to expire, Monet decided to move his family again. In a letter to Durand-Ruel dated 5 April, Monet explained the need to relocate. The lease on the house in Poissy would expire in ten days, but Monet sought more than a temporary solution to his housing problems. He wrote: "If I were settled somewhere permanent, I could at least paint and put a brave face on it…tomorrow and the days after, I'm going out until I've found a place and a house that suit me."

A RURAL PARADISE

Over the years, Monet had often travelled the northwest train line from Paris to his native Le Havre. He recalled that there were a number of appealing hamlets along the Seine valley, and it was there that he decided to begin his search. He took the train to Vernon, where he changed to a local line headed toward Gisors. The journey took him through the serene countryside along the River Epte, a tributary of the Seine. There was a timeless quality to the region, nearly untouched by industrial development, and the marshes and meadows provided an idyllic setting for the villages he saw along the way. Of these, he selected Giverny, a tiny settlement of less than three hundred inhabitants. It appeared to be a rural paradise, with narrow streets and half-timbered houses that had survived unchanged over the centuries.

Giverny provided a solution to Monet's practical needs. Small and undeveloped — most of the population farmed or practised cottage industry — Giverny was affordable. Located forty-five miles northwest of Paris, it had yet to attract suburban commuters and weekend visitors from the city. There were excellent schools for the older children in nearby Vernon; the younger ones could attend the village school until they, too, were old enough to board. The natural features of the region were beautifully varied, with rounded, rolling hills to the north, low marshlands and stands of poplars along the banks of the Epte, and, farther south, the meadows of wild iris and the cultivated fields of poppies and wheat. The local train line to Vernon had a limited schedule, making travel inconvenient, but with advanced planning Monet could make

regular trips to Paris for business and for the monthly gatherings of the members of the Impressionist Circle at Café Riche.

On the southern outskirts of the village of Giverny, Monet found a comfortable house for his family. The area was known as *"le pressoir,"* reflecting the region's traditional production of cider. The modest two-storey house was designed in the local, tile-roofed style, but a former owner, who had spent time in Guadeloupe, had covered the exterior in pink stucco and painted the shutters grey, giving the house a distinctive air. (Monet painted the shutters green, perhaps in recollection of his second house in Argenteuil.) Monet signed a lease with the current owner, Louis-Joseph Singeot, which allowed him immediate occupancy of the house and its two and a half acres of land. This included a garden, a small orchard, and several outbuildings, all surrounded by a wall.

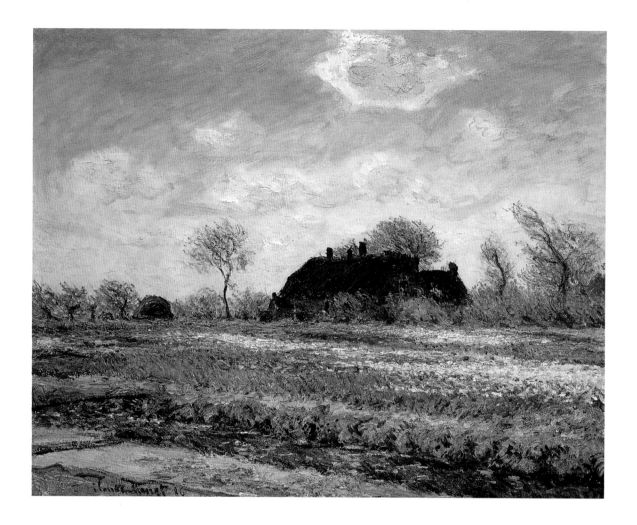

Assisted by the older children, Monet transported the family's belongings from Poissy on his studio boat. Alice followed on the train with the younger children, and the whole family settled in during the first weeks of May. Before he could begin painting, Monet undertook some minor renovations to accommodate the demands of his work: converting the west wing of the house into a studio and building a shelter on the banks of the Seine to house his studio boat and other small craft and store his easels and canvases. These tasks proved to be more time consuming than Monet expected, and he complained in a letter to Durand-Ruel, written on 5 June: "Dealing with my boats has been a great distraction. I had to accommodate them safely because the Seine is some distance from the house." Other tasks also kept him from starting new canvases, for, as he explained to his dealer, he had to attend to the

Tulip Fields at Sassenheim, near Leiden, 1886, Sterling and Francine Clark Art Institute, Williamstown, Massachusetts. When Monet travelled to The Hague in 1886 he was struck by the brilliantly coloured blossoms, separated into beds according to individual hue. He painted the tulip fields five times, but he regretted that the colours available to an artist could not match the vivid purity of those in nature.

garden, "which claimed all my time, because I should like to grow some flowers in order to be able to paint in bad weather."

THE GIVERNY GARDEN

At the time Monet leased his new home, there was little in his garden that pleased him. Immediately in front of the house were several flowerbeds, edged with a clipped box border. A wide path, known as the Grande Allée, ran from the door of the house to the gate in the enclosing wall, dividing a mixed plot of flowers and vegetables also edged in box. A line of trees flanked the path, spruce alternating with cypress, casting the surrounding flowerbeds into shadow. Also on the property was an apple orchard, known as the "Clos Normand," as well as six pairs of lime trees to the west of the house and a pair of yews near the door at the top of the Grande Allée. With the help of his children, Monet pulled up the box edging and planted flowers around the base of the house. His friend Gustave Caillebotte, also an avid gardener, came for a visit in June to lend his expertise. Family members were pressed into every task, and in later years Monet recalled: "All of us worked in the garden. I dug, planted, weeded, and hoed myself; in the evenings the children watered."

Monet approached his task with energy and patience; he recognized that, for the time being, subjects for his art had to be sought elsewhere. Since his days at Poissy, he had directed his artistic vision outward, away from his home, travelling throughout Normandy on painting expeditions. During the winter of 1882, he worked at Dieppe and Pourville, painting the majestic cliffs that rose above the choppy waters. On occasion, he was accompanied by Alice and his extended family – they joined him in Pourville during the summer of 1882 and in Etretat in the autumn of 1885 – but for the most part, Monet travelled alone. Harsh weather did not deter him, and he set up his easel to paint in the open air even in the worst conditions. Pursuing his art became a gruelling physical challenge that often exhausted him.

In December 1883, Renoir persuaded Monet to join him on a journey south, to visit Cézanne in L'Estaque in the south of France and to explore the possibilities of painting along the Mediterranean coast. The effect of the light – warm-toned and gentle even in the winter – astonished him, and in the following January, Monet returned to the Mediterranean and remained on the Italian Riviera for three months. Writing to Alice from Bordighera, he shared his delight over the delicate and pervasive pink light, which he admitted was impossible to emulate. On 5 March

Field of Yellow Irises at Giverny, 1887, Musée Marmottan-Monet, Paris.
During his first years at Giverny, Monet sought subjects in the fields and meadows that
surrounded his home. In the spring, wild iris grew in the marshes. Monet concentrated
on the chromatic resonance of the flowers with their surroundings, painting the bright
blossoms between green foliage dappled with blue shadow and the blue-toned misty hills
with a crown of green.

1884, he described the roses and carnations which were growing wild, an abundance of flowers that seemed to have been "charmed out of the ground." He sorely missed Alice's company in this idyllic setting, musing "How happy we'd be here and what a pretty garden we would have."

Through Monet's hard work and persistence, his professional reputation continued to rise. In 1880, he decided to forego participation in the fifth Impressionist Exhibition and submit two works to the official Salon: one was accepted. He also exhibited his work independently. The financial tribulations he faced in 1881 prevented him from entering work in the sixth Impressionist Exhibition, but in the following year the seventh Impressionist Exhibition featured thirty-five new paintings, many from his expeditions to the Channel Coast. But in 1886, Monet again declined to exhibit with the Impressionists, withholding his work from the eighth and final exhibition.

Despite his own financial difficulties, Durand-Ruel supported Monet's endeavours, and in 1882, the dealer commissioned a set of thirty-six decorative panels for the dining room of his Parisian apartment. For the commission, which spanned four years, Monet selected floral themes – peonies, poppies, daffodils, and chrysanthemums – inspired by the flowers he had planted in front of his house. Reluctantly, Monet agreed to allow Durand-Ruel to include his works in an American exhibition, and in 1886, the dealer's first Impressionist exhibition in his New York Gallery featured nearly fifty of Monet's paintings. As a result, Monet gained international acclaim – as well as American patrons. He feared that Durand-Ruel would monopolize the distribution of his work, so he sought additional representation, exhibiting his paintings with Georges Petit and Theo van Gogh. He now also insisted on setting his prices himself and took the initiative of cultivating patrons on his own.

Late in April 1886, Monet travelled to The Hague. His brief stay coincided with the blooming of the tulip fields. Struck by the spectacle of the brilliant beds, separated by colour like pigment on a palette, Monet produced five canvases, setting up his easel in the fields near the village of Sassenheim, between Leiden and Haarlem. He claimed that the natural array of colour daunted him, and while he praised the beauty of the "enormous fields in full bloom," he saw them as an insurmountable challenge, "enough to drive a poor painter crazy – impossible to render with our poor colours." But the paintings of the bulb fields contradict his feelings of inadequacy. Using pure pigments, placed side by side like the flowers in the field, Monet captured the natural spectrum, as well as the luminous effects of the volatile sky (see page 38).

Theodore Robinson, *Claude Monet in his Garden, c.* 1887,
Terra Museum of American Art, Chicago.
Dressed in wooden clogs and a cloche hat, Monet posed
for this photograph in his flower garden. In the early stages
of transforming the garden to reflect his artistic vision,
Monet worked alongside the gardeners he hired part-time.

During his two-week stay, he was equally intrigued by the horticultural techniques used in bulb cultivation. He learned that to strengthen the bulbs the farmers plucked off the blooms when they reached their peak, a practice he would later employ in his own garden. The sight of the bright flowers, discarded in vivid heaps on the local canals, appeared to him like "coloured rafts in the blue reflection of the sky." The effects of his visit were both immediate and long-lasting. In planting his own garden, Monet began to mass flowers in individual beds distinguished by colour to accentuate their singularity of hue, and later, in his water garden, he recreated the visual magic of bright blossoms gliding on a glimmering surface.

Increasingly, Monet sought to find his subjects in the environs of Giverny. Captivated by the beauty of the emergence of spring flowers, he set up his easel in the orchards to paint the fruit trees as they came into bloom. In 1887, Monet turned his attention to the fields of wild iris which grew in the nearby marshlands. With a limited palette, pure pig-ment, and a short, descriptive brush stroke, Monet returned to the technique he had used to capture the beauty of the tulip fields. In his paintings of the iris fields, the warm yellow flowers, rising above their cool green foliage and seen against a backdrop of misty violet hills, appear as bright bands of colour, a natural vision under a cloud-strewn sky (see pages 40–41). He also continued to work in series, seeking local subjects, such as poplars and grainstacks. These gave him the opportunity to study

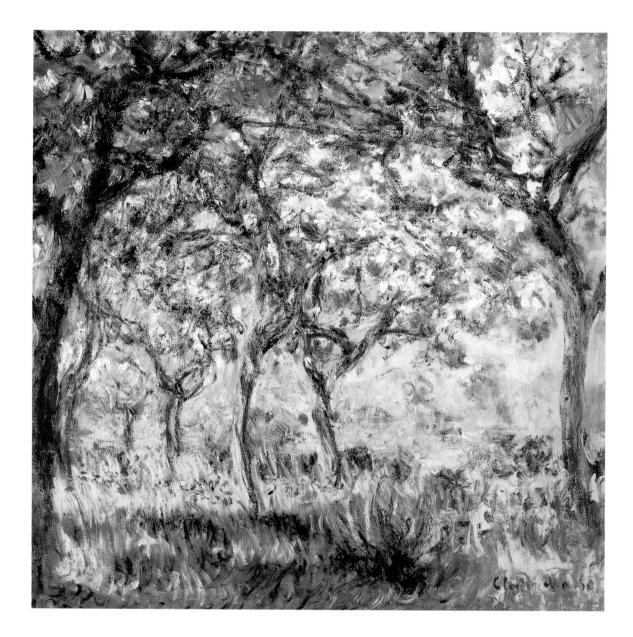

the subtle variations of the fleeting effects of light and atmosphere as the
hours passed and as one season gave way to the next.

Later that spring, Monet focused the same perceptions on his own
garden. As the peonies came into bloom, he portrayed their bright bursts
of colour, ranging from shades of deep scarlet to pale pink. Again, he
used unmodulated tones, applied in thick, short strokes of pigment,
emphasizing visual sensation over descriptive form. But, unlike his
depictions of the iris fields, which were painted from a distant position

to enhance sweeping effects of the bands of colour, Monet viewed the peonies at close range (see page 46). The canvases that depict the bushes blooming under protective straw awnings feature vivid, high-toned hues that dissolve the contours of the flowers and foliage into a rich pattern of surface decoration, with little regard for the traditional concerns of representation and perspective. In the next year, he painted his first image of the Grande Allée, depicting Alice's daughter Germaine walking toward the house with her arms loaded with flowers.

In 1890, with the confidence of his increasing prosperity, Monet made a crucial decision. The lease for his home at Giverny was about to expire, and, rather than face all the disruption and anxiety of moving out, Monet purchased the house and its surrounding property. Giverny had provided the serene stability that Monet had sought after his troubled years in Vétheuil and Poissy, and he strongly believed that he would "never again find such an abode and so beautiful a neighbourhood." After some negotiation, Monet acquired the property in November for 22,000 francs. On 14 December 1890, he wrote to Durand-Ruel exclaiming: "The house is mine at last."

A SOURCE OF STRENGTH

For Monet, Giverny was more than a home for his family; it was a source of strength and renewal. In the spring of 1892, when he was on an extended stay in Rouen, painting his series of the cathedral, his letters to Alice reveal that he longed to return home. Monet was painting nearly twelve hours a day and was always on his feet, working nine canvases at a time. "It's murderous," he lamented to Alice, "and to think I drop everything, you, my garden, all for this."

With the property now his, Monet invested even more energy and expense into the transformation of his garden. He steadily thinned the number of trees on the property – particularly in the apple orchard, where he replaced the apple trees with more decorative and less densely planted Japanese cherries and apricots – but he was most passionate about surrounding his home with flowers. On either side of the Grande Allée, he planted a selection of his favourites: irises, daffodils, oriental poppies, roses, and peonies. In contrast to the neatly shaped beds, defined by borders that conformed to the classic rules of French gardening, Monet preferred a looser, more informal appearance, featuring densely massed beds, differentiated not by borders, but by colour and height. He composed his garden in the same way that he composed his paintings; his main concern was visual sensation.

By cultivating the garden to his own design, Monet projected his artistic vision onto nature, but he painted the garden in a way that was fully spontaneous, with a result as fresh and immediate as his earlier *plein-air* work. As seen in a painting of 1895, featuring his stepdaughter Suzanne on the Grande Allée in the midst of full-blown, late summer dahlias and roses (see page 37), Monet embraced a single aesthetic for his art and his garden, based on his fleeting impressions of colour bathed in natural light.

Alice, who married Monet on 16 July 1892, more than a year after the death of her estranged husband Ernest Hoschedé, rarely objected to Monet's plans for their house and garden. But she was particularly fond of an original feature of the property: the stands of cypress and spruce trees that flanked the Grande Allée. In the height of the summer, drooping branches of the cypress trees formed a welcome arch of shade over the path, and the dark trunks of the spruce trees set an elegant, processional tone to the approach to the house. Monet objected that the trees were blocking the light for his flowers, and he made plans to remove them. At first, he tried to accommodate Alice's wishes, thinning the lower branches to let in more light. He then took a more drastic step, cutting off the tops of the trees and training climbing roses around the denuded trunks. In a group

ABOVE *Peonies*, 1887, National Museum of Western Art, Tokyo (Matsukata Collection). The peony bushes, coming into bloom under protective straw awnings, presented Monet with one of the first subjects from his Giverny garden. The deep scarlet red blossoms strike an unsettling contrast with the dull blue-green foliage that surrounds them. He painted the canopy in short strokes of pink and orange, suggesting the radiant sun that shines above. One of three similar canvases, *Peonies* is conceived as a vivid colour study, bathed in natural light.

RIGHT *Irises in Monet's Garden*, 1900, Musée d'Orsay, Paris.
Partial to blue and violet flowers, Monet planted irises in abundance, massing beds of them in bands in front of his house. He painted them with thick, short strokes of pure pigment, laid on side by side, rather than mixed or scumbled, to approximate their natural fresh appearance. One visitor claimed that the bright banks of irises seemed to be floating, "like a haze of lilac in the sun."

of paintings of the Grande Allée, dating between 1900 and 1902, the trees appear as minor elements, seen in the dark green shadows cast on the path by the cypress branches and the bold vertical accents of the spruce trunks, with their rich, sienna-red hue (see pages 48–49). But the paintings derive their beauty and energy from flickering strokes that describe colourful flowers, ranging from the mosaic of salmon pink and garnet nasturtiums in the low beds lining the path to the bands of blue, mauve, violet, and lavender created by the banks of iris densely planted on either side.

Through time and labour, Monet patiently transformed the garden at Giverny to reflect the nature of his imagination, and, in time, the garden would transform his art. Monet's passion for his garden permeated all his interests. He read avidly on the subject; after visiting Giverny, the journalist Maurice Guillemot observed that Monet read "more catalogues and horticultural price lists than articles on aesthetics." Monet cultivated friends who shared his great love of gardening, including Caillebotte, the novelist Octave Mirbeau, and the critic Gustave Geoffroy, with whom he exchanged advice as well as seeds and clippings. He built two greenhouses and hired six gardeners, good-naturedly admitting, "all my money goes into my garden."

As the years went by, Monet became disinclined to make his regular trips into Paris, encouraging his friends, his dealers and a few favoured patrons, to come to Giverny. He even curtailed his painting expeditions, for, as he confessed to Alice, it no longer mattered where he went: "My heart is always at Giverny."

ABOVE *The Grande Allée*, Archives of American Art, Smithsonian Institution, Washington D.C.
This early photograph of the Grande Allée records the vista that Alice preferred.
She liked the subtle yet elegant formality of the tree-flanked path that led from the
gate to the house. Monet, despite her protests, first cut back the branches, and then
thinned the trees, eventually clearing them to allow more direct sunlight on his flowers.

RIGHT *Main Path Through the Garden at Giverny,* 1902, Österreichische Galerie Belvedere, Vienna.
In this view of the Grande Allée, looking north toward the house, Monet portrays the
remaining original trees, with their deep-toned bark, casting dusky shadows on the
pale gravel path. Deep in the distance, the stucco façade provides a delicate pink accent.
In contrast, the warmth of the garden's summer palette is seen in the bright fuchsia
blossoms and vivid scarlet blooms, luminous under a hot sun.

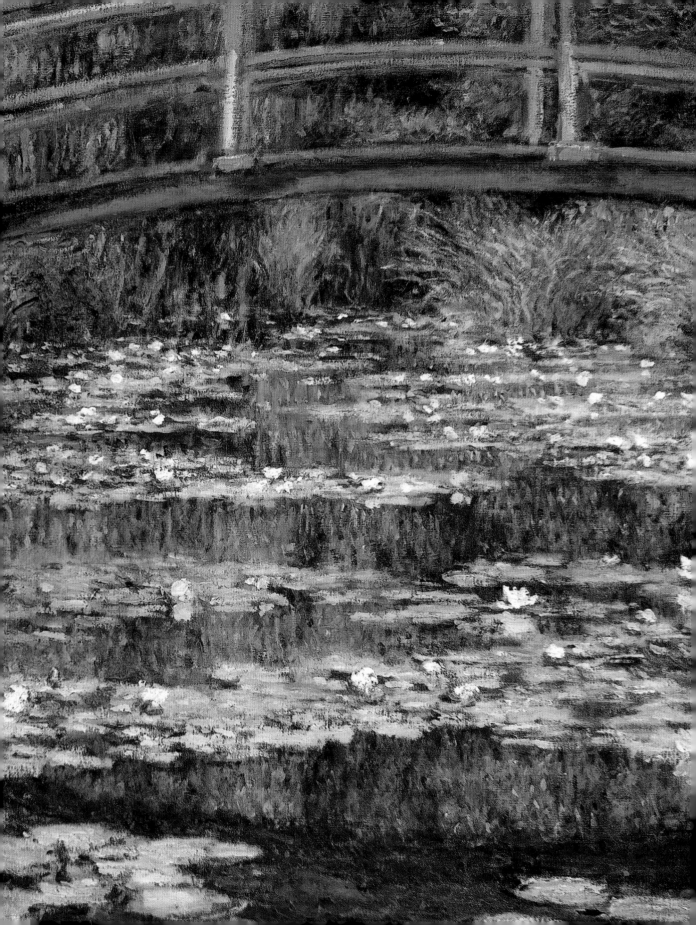

Chapter 3
THE WATER GARDEN

In the early days of February 1893, Monet purchased a parcel of land adjacent to his home in Giverny. Just under an acre, it consisted of a meadow and a small pond previously used as a watering hole for farm animals. It was bordered on one side by railroad tracks and the *chemin du Roi,* the thoroughfare that ran parallel to the front wall of his garden, and on the other by the Ru, a minor tributary of the Epte. The marshlike condition of the land allowed Monet to bring into being a "dream" that, according to his stepson Jean-Pierre, he had long cherished. Monet envisioned the pond transformed into a water garden, with bright aquatic lilies floating on its still surface and reeds, willows, and iris growing along its banks.

To implement his plan, Monet needed to divert the course of the Ru, forcing it to loop in and out of the pond to refresh the stagnant water. On 17 March, he applied to the local authority for permission to build two light footbridges across the Ru and to install a *prise d'eau* (water trough) that he claimed would not affect the water level or the flow of the connecting River Epte. Monet assured the *préfet* of the Eure that his sole interest was the cultivation of aquatic plants. But the residents of Giverny were suspicious of his plan. They were unfamiliar with the new, hardy hybrid lilies which Monet discovered in the horticultural catalogues, and they feared that these "exotic" plants would spread through the rivers, choking the flow and poisoning the waters.

Monet was painting in Rouen when he received news that his request had been denied, and he vented his anger in a letter to Alice: "Throw the plants into the river; they will grow there. I don't want to hear another word about it, I want to paint. To hell with the natives and the engineers."

The Japanese Footbridge
(detail), 1899

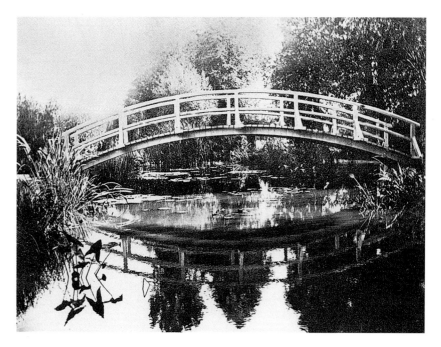

Monet's request was raised in two subsequent hearings, and on 17 July, he submitted a new petition. In it, Monet explained that his sole purpose in constructing the water garden was "to delight the eye," although he added that it would "provide motifs to paint." He dismissed the fear that his flowers would poison the waters, noting that reeds, irises, and even certain types of lilies grew wild along the river's banks. The motives of those who insisted that his plan would endanger public health seemed to Monet to be the result of "ill-will," reflecting a xenophobia against Parisians. He concluded by offering a compromise: he offered to limit the recirculation of his pond to evening hours, when no one else was using the water. To bolster his case, he enlisted the help of the journalist C.F. Lapierre who, as former manager of the *Nouvelliste de Rouen,* had influence throughout the region. Lapierre personally delivered the strongly worded letter to the *préfet,* and within days, permission was granted.

Over the next few months, hired workmen transformed the marshy pond. The old growth of poplar and aspen trees was interspersed with weeping willows; the graceful spill of their branches over the pond softened its perimeter and heightened its sense of enclosure. Flowerbeds were designed in circles and curves, undulating along the banks of the pond like the natural flow of a river. Asian plants, including Japanese peonies and bamboo, gave the garden a rarified air, which Monet balanced with

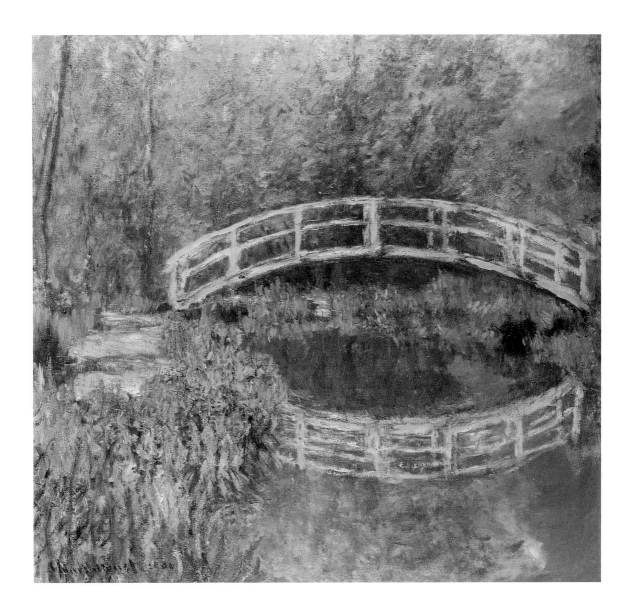

plantings of local flowers, such as heather, hydrangeas, rhododendrons, and azaleas. The water lilies were added to the garden the following year. Monet also hired a full-time gardener whose sole responsibility was to care for the water garden.

In 1895, Monet had a small, arched footbridge constructed near the western extent of the pond, positioned to correspond to the main gate of his house on the axis of the Grande Allée. In later years, Monet described the creation of the garden in the most simple terms: "I love water, but I also love flowers. That's why when the pond was filled, I wished to decorate it

with plants. I took a catalogue and made a choice off the top of my head. That's all." But in the water garden, Monet explored the most complex relationship of his art with its subject: as a gardener he shaped the elements that inspired his art and as a painter he expressed the boundless beauty that he discovered in nature.

JAPANESE INFLUENCES

In the summer of 1905, the critic Louis Vauxcelles visited Monet at his home in Giverny. Arriving in the afternoon, he was greeted by the painter, who hurriedly guided him to the water garden to see the lilies before they closed. In an account of his visit published that December in *L'Art et les Artistes,* Vauxcelles recalled its contemplative beauty, "a setting that enchants us rather than inspiring our awe, a dreamlike setting that is extremely oriental." Vauxcelles was not alone in detecting an Eastern sensibility of the water garden. Tadamara Hayashi, a print dealer who had become Monet's personal friend, insisted that the garden emulated those of his native Japan. But Monet denied that his garden imitated Japanese models, claiming only the bridge was an example of the *'genre Japonais.''* The plants he selected were, for the most part, Western, even native to the region, but the tranquil and meditative atmosphere – in contrast to the vivid vitality of the flower garden – evoked a perfect balance of art and nature. This was epitomized for Monet's generation in *ukiyo-e,* the great woodblock print tradition of Japan.

At the dawn of the seventeenth century, Ieyasu, the head of the Tokugawa Shogunate, united the warrior clans of Japan. Under the Tokugawa Shogunate (1600–1867), the nation enjoyed unprecedented peace and prosperity, and the capital Edo (now Tokyo) became a centre for the arts. In this sophisticated atmosphere, a new form of print-making emerged, a multi-block colour process, featuring mundane subjects which appealed to popular, rather than elite, taste. Known as *ukiyo-e* (or pictures of the floating world, referring to the pleasure districts of Edo), the prints recorded the visual panorama of contemporary Japan, including celebrities such as actors and courtesans, and picturesque views of favourite tourist sights. The late eighteenth and early nineteenth century marked the zenith of the *ukiyo-e* tradition, as seen in the work of the masters Kitagawa Utamaro, Katsushika Hokusai, and Ando Hiroshige. To preserve cultural purity, the Tokugawa Shogunate enforced an isolationist policy, closing Japan against almost all foreign influence for nearly two hundred and fifty years.

Ando Hiroshige, *Inside Kameido Tenjin Shrine* from 'One Hundred Famous Views of Edo', 1856, Museum of Fine Arts, Boston.
French collectors of *ukiyo-e* prints believed that Japanese artists enjoyed a more intuitive relationship with nature than their Western counterparts. While Monet appreciated the beauty and balance in their landscapes, he admired them most for invoking the spirit of a place with an economy of means.

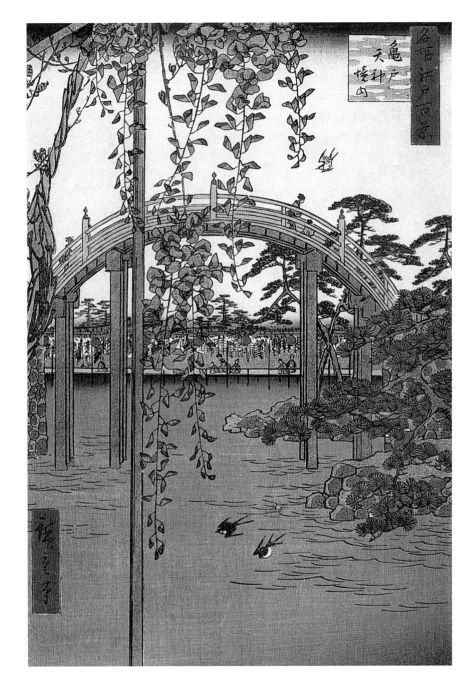

In 1853, using gunboat diplomacy, the American Commodore Matthew Calbraith Perry forced Japan to open up to Western trade. During the next few decades, Japanese goods flowed freely into the European and American markets, and *ukiyo-e* prints, regarded in Japan as a cheap commodity, were

avidly sought by discerning art collectors and the more advanced artists in Europe.

Ukiyo-e captivated the artists of the Impressionist circle. With their simple, yet bold and masterful aesthetic, the colourful prints struck a sympathetic chord with artists intent on portraying the fleeting spectacle of their own contemporary world. But, with a lack of understanding of Japanese tradition and culture, Western artists and collectors romanticized the art of Japan as indicative of a society untouched – and therefore untarnished – by Western progress. In the restrained and serene depiction of landscape of the woodblock prints, Western critics discerned a special relationship between Japanese artists and nature, and they identified it as evidence of an innocent sensibility in a Eden-like setting. Siegfried Bing, one of the most prominent and knowledgeable dealers of *ukiyo-e,* asserted that Japanese artists found in nature their "sole, revered teacher" and their "inexhaustible source of inspiration." Gustave Geoffroy concurred, claiming that "life in the open air [in Japan] mingles man and nature together," allowing the artists of Japan to develop a deep and instinctive response to the natural world.

Monet shared the passion of his generation for the art of Japan as seen in *ukiyo-e.* He began to acquire prints as early as 1871 when he visited Holland, and by the time he created his water garden he had amassed an impressive collection. On 1 February 1893, just days before he submitted his first request to divert the Ru to the *préfet* of Eure, he travelled to Paris, to see an exhibition of prints by Utamaro and Hiroshige at Durand-Ruel's gallery in Paris.

What fascinated Monet was the skill, rather than the setting, that he observed in the prints. They captured the nuances of changing light and atmosphere with the most economical means of expressive line and unmodulated colour. *Ukiyo-e* reflected Monet's own desire to work in a state of inspired sympathy with the natural world.

NEW WORKS

As with his flower garden, Monet refrained from painting the water garden during the first years of its cultivation. His experience had taught him that only time could bring a garden into its full beauty, and that time, as well, was needed to fully comprehend its potential as a subject. He had recently completed his magisterial series of thirty paintings of the cathedral in Rouen, and the challenge of capturing the transformative effect of light from early dawn through darkening dusk had only served

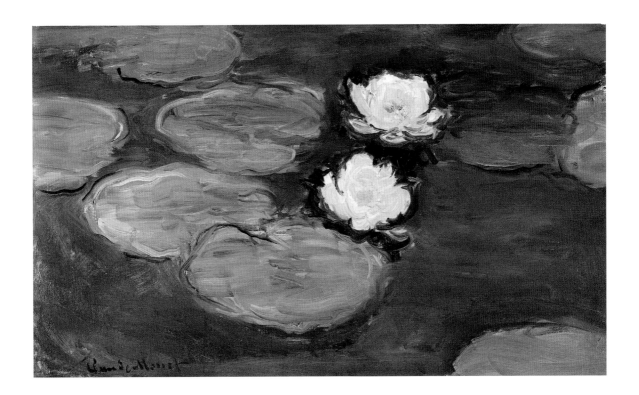

Water Lilies, 1897,
Los Angeles County
Museum of Art.
Monet's close
contemplation of the
water garden as it came
into full bloom inspired
a set of studies in 1897.
In each, the water spans
the canvas from edge to
edge, and a few water lilies,
buoyed by platelike pads,
glide across the surface.
The petals of the lilies are
painted in clear, luminous
hues, glistening against
the duller, more muted
tones of the pads and
surrounding water.

to strengthen Monet's belief that close observation was essential to his artistic expression. He once explained that "the subject is secondary. What I want to reproduce is that which is between the subject and me."

In November 1894, Paul Cézanne visited Giverny, taking a room in the Hôtel Baudy near Monet's home. The subtlety of Monet's new works in series, notably the *Poplars* and *Rouen Cathedral* astonished Cézanne, who felt compelled to admit that Monet possessed "the only eye and the only hand that can follow a sunset in its every transparency and express its nuances on the canvas." Earlier that year, Monet had undertaken two series on a smaller scale, turning his keen eye to local subjects – *The Seine at Port-Villez* and *The Vernon Church* – under varied atmospheric effects such as mist, fog, evening light, and full sun. Durand-Ruel had pressed Monet to exhibit his new paintings, but Monet repeatedly told his dealer that he was simply not ready. He finally agreed to a solo exhibition which opened in Paris on 10 May 1895. Among the fifty paintings exhibited, twenty represented his cathedral series; also included were a selection of his views of the Seine and of the church in Vernon.

The exhibition prompted Georges Clemenceau, the publisher and founder of the journal *La Justice,* to take on the guise of "an art critic for

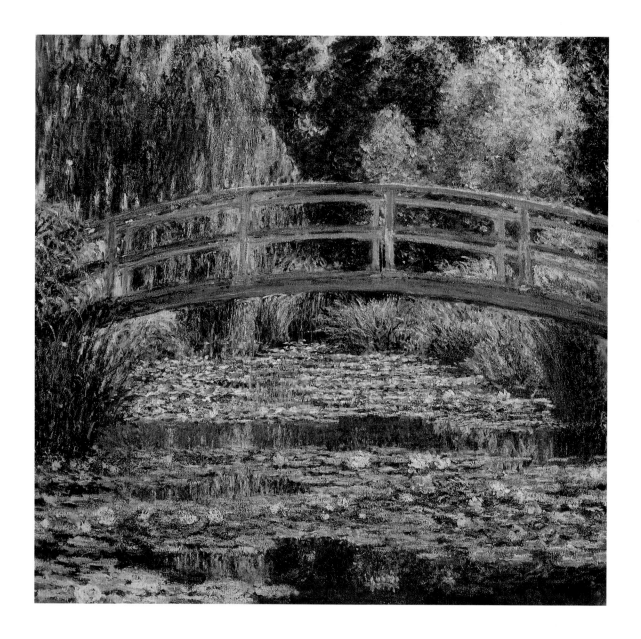

a day" and share his admiration for the painter's works in series. Monet and Clemenceau had first met in the early 1860s, but in 1886, a renewed contact led to a deep friendship based on shared ideas about art and politics, as well as passion for gardening. Clemenceau had seen the cathedral paintings in Monet's studio, but to behold twenty of the paintings hung together in the galleries was, for him, a "revelation." He urged his readers to go to the exhibition and take a "big, circular glance" to experience the individual canvases as a whole, "the lasting vision, not of twenty, but of a

hundred, of a thousand, of a million versions of the eternal cathedral in the immense cycle of the suns." He then challenged the President of the French Republic, Félix Faure, to purchase the works for the nation, as a legacy for future generations.

Monet spent the first four months of 1895 in Sandviken, a village near Oslo in Norway, visiting his stepson Jacques. While he was there he painted the fjords at Christiania, as well as Mont Kolsaas and red houses in the snow. The light effects, varying with times of day and weather conditions, again intrigued him. But upon his return to Giverny in April, Monet turned his attention to his new garden. Using stones taken from two benches which had flanked the Grande Allée, Monet had a new bench built and installed it on the far side of the Japanese bridge. There Monet could quietly observe his garden, immersing himself in the sensate experience of the rustling reeds, the light filtering through the willow branches, and the shadows and reflection on the glassy surface of the pond, dappled with the floating lilies.

Before leaving for Norway, Monet had painted the pond for the first time, in the frigid early days of January, but its bare, sparse appearance failed to engage his imagination. He returned to the subject again that summer, painting two views of the Japanese bridge (see page 53). Using a pale palette of pink, yellow, and blue, Monet captured the bleaching effect of the high, hot summer sun. But Monet's frustration with his early depictions of the subject is evident in the disjuncture of its separate elements. Each visual detail – the bridge, the path, the flowers on the bank, and the reflections on the water – remains distinct from one another. Rather than creating a harmonious ensemble, Monet moved from form to form and from colour to colour, as if a full understanding of the subject could only be obtained through the careful inventory of its parts. After painting only two canvases, Monet turned his attention elsewhere. For the time being, the power to paint the water garden eluded him, but he continued to spend hours sitting near the pond, contemplating its beauty and gleaning an understanding of its subtle aesthetic through his calm and persistent observations.

MORNING ON THE SEINE

Monet began a new series in 1896, which occupied him well into the next year. His subject was morning on the Seine, and in more than fifteen canvases, he captured the ephemeral effects of fog and mist over the water, as the cool light of dawn gave way to the gentle illumination of the rising sun. In August 1897, the essayist Maurice Guillemot visited Monet, and

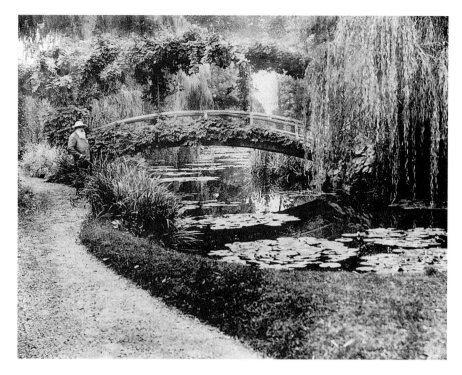

accompanied him in the early morning to the site near the confluence of the Epte and the Seine where the painter set up his easel. Guillemot compared the suite of paintings – noting that the artist worked on fourteen canvases at once – to a "study in scales, a translation of a single identical motif whose effect is modified by the time of day, the sun, and the clouds." After the morning mist had burned away, Monet took his guest into the studio in his house, which Guillemot described as more of a sitting room. Earlier that year, Monet had an outbuilding constructed near the house; the first floor was used by his gardeners, but the second was divided between additional rooms for his children and a new studio where he could work in the winter.

After lunch, Monet escorted Guillemot to the water garden, where they sat and conversed under the shade of a parasol. Guillemot was entranced by the glassy pond and its abundance of lilies: "Upon that immobile mirror float water lilies, aquatic plants, unique species with broad, spreading leaves and disquieting flowers of a strange exoticism." Later they returned to the studio, where Monet showed his guest a number of studies of the pond. Closely observed, each canvas featured nothing more than a span of water and a few blossoms, brightly painted against the muted tones of the lily pads and the surface of the pond (see page 57). Some views included reflections

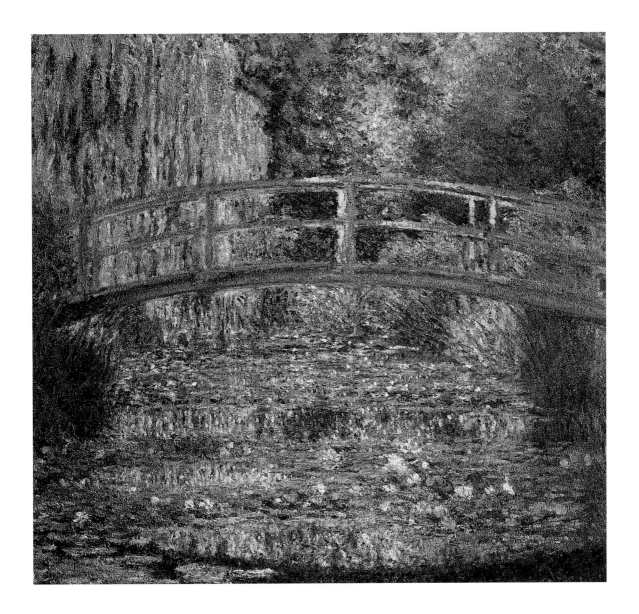

of the branches of the trees, recalling the subtle motif that graced the series that he was painting of the Seine in the delicate light of the morning.

In his account of the visit, published in the 15 March 1898 edition of *La Revue Illustrée,* Guillemot revealed that these modest studies were models for a decorative ensemble inspired by Monet's contemplation of his pond. "Imagine a circular room in which the dado beneath the moulding is covered with [paintings of water], dotted with these plants to the very horizon, walls of a transparency alternatively green and mauve, the calm and still waters reflecting the opened blossoms." Guillemot's comment

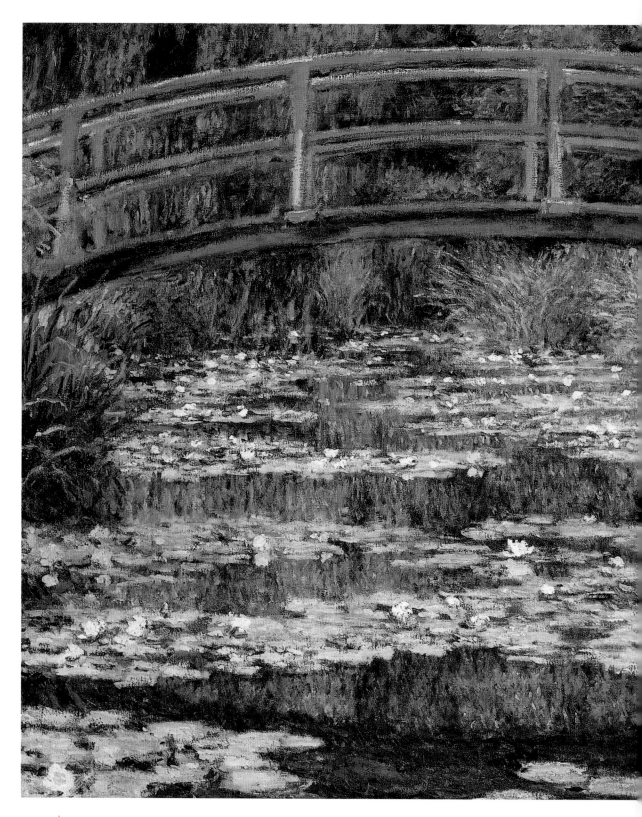

recalls Clemenceau's suggestion that to comprehend the unity in Monet's work in series a viewer must take a "big, circular glance." But the surviving eight studies hardly constitute a series; rather they were the first tentative impressions through which Monet forged a new, more intimate bond with nature as he developed the artistic capacity to express the wonders of his pond in his art.

Late in his life, Monet reflected upon his initial hesitation to paint the pond. "It took me a long time to understand my water lilies," he admitted. His motivation to plant them, he explained was "pure pleasure... I grew them without thinking of painting them." The hours he spent in quiet contemplation, seated on his bench and looking at the water, guided his vision, for experience had taught him that "you don't absorb a landscape a day." And when time and familiarity led to insight and understanding, Monet seized the moment to express in his art what could never be explained in words: "And then, all of a sudden, I had the revelation of the enchantment of my pond. I took up my palette."

After painting his initial water lily studies, Monet seems to have taken a break from his art. No works exist that can be dated between the winter of 1897 through the spring of 1899. Writing about the artist in 1899, the American collector William Henry Fuller asserted that it was Monet's habit to destroy his inferior endeavours and that in the summer of 1898, he disposed of a group

The Japanese Footbridge, 1899, National Gallery of Art, Washington D.C. Monet shifted his perspective in this painting by raising the Japanese Bridge to the upper perimeter of the canvas. The water nearly filled his field of vision, and he painted the fleeting reflections of the trees and the slow motion of the lilies. The bridge frames the complex patterns on the surface, a stable canopy arcing above it and a shimmering reflection in the waters below.

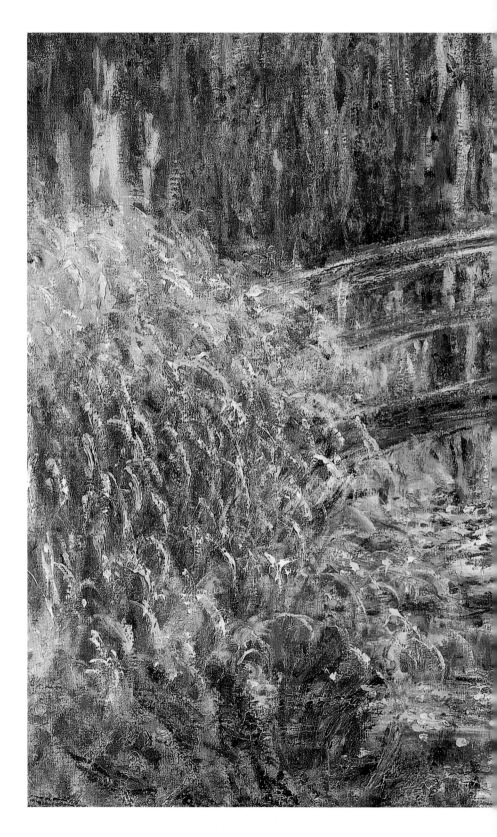

Water Lily Pond, Symphony in Rose (detail), 1900, Musée d'Orsay, Paris. Monet painted six new views of the Japanese bridge in 1900. In chromatic contrast to the cool tonality of the earlier works in the series, Monet now experimented with heated tones of hazy yellow, rich violet, sienna brown, and rose red. Similarly, his brush work loosened, a calligraphic line replacing the more precise dabbing stroke. Strong, sure lines describe the form of the drum bridge, linking the motif to the confident renderings of the serene landscapes of the *ukiyo-e*.

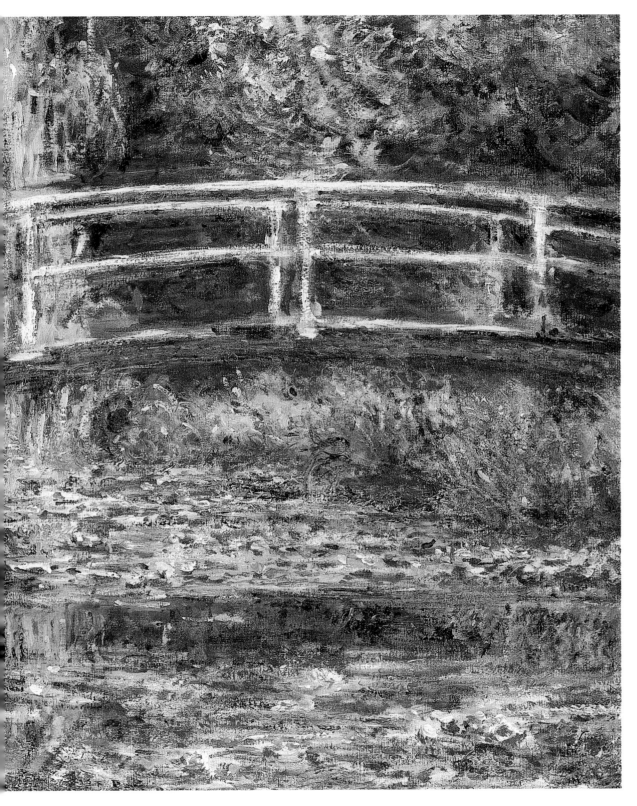

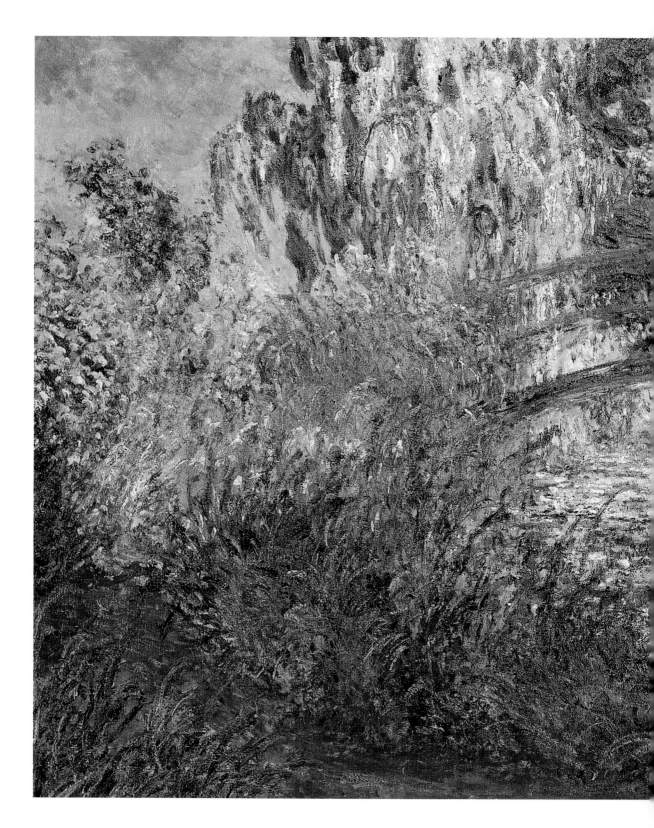

of unfinished paintings in a bonfire, believing that they "were not worthy of his name." Whether works from this time perished can only be a matter of speculation. It is more likely that the early months of 1898 left him little time to paint, for he was preparing for a large solo exhibition at the Galerie Georges Petit in Paris. Opening on 1 June 1898, it featured sixty-one works, including eighteen canvases from the series *Morning on the Seine*. The exhibition drew wide acclaim. The journal *Le Gaulois* published a special Sunday supplement devoted to Monet and his art, while in the *Revue Populaire des Beaux-Arts,* Georges Lecomte praised the painter as "the epic poet of nature."

While the new year brought further recognition for Monet, with exhibitions in Paris at Galerie Durand-Ruel and Galerie Georges Petit and in New York City at the Lotus Club, he also suffered some personal tragedies. Early in January his old friend the artist Alfred Sisley died, leaving his wife and children in dire straits. Monet's sense of loss was great, but his sense of concern for the family even greater, and he organized an auction to raise funds to help them. Far more devastating

Path along the Water Lily Pond, 1900, private collection.
To express the fleeting play of light on the pond, Monet dissolved the surface of his painting into a glittering mosaic of colour. The canvas glistens with bright tones of pink, red, periwinkle blue, and pale yellow. Feathery reeds and grasses tremble on the banks of the pond, while the massed lilies on the water's surface shimmer with an opalescent opulence (see detail above). The path in the foreground flows like a river. Only the taut arc of the bridge is still.

was the death of his beloved stepdaughter Suzanne on 6 February after a long illness. At the time, Alice was ill with bronchitis; she regained her health, but she never recovered from the grief of losing her daughter.

VIEWS OF THE POND

In July, 1899, Monet once again picked up his palette and opened his imagination to the enthralling beauty of his water garden. Over the course of the summer, he worked on twelve different canvases, each depicting a view of his pond spanned by the Japanese bridge. In contrast to the muted tones of the water lily studies of 1897, the *Japanese Bridge* pictures of 1899 have a sparkling tonality, with bright, fresh colours evoking the cool foliage and still water, as well as the petals of the blossoms. By working in the height of the summer, Monet was able to portray the garden in all its resplendence. In these lush and luminous images, Monet celebrated the regenerative power of nature, as seen in the verdant veils of the leaves on the trees, the dense growth of reeds on the water's banks, and, most of all, the opalescent lilies floating on the shimmering surface of the pond.

Monet's mastery of atmospheric effects, honed in his most recent work in series, attained new subtlety and evocative power in these depictions of the Japanese bridge. The dense growth of trees that forms the background of each canvas, blocks the sky, but Monet expressed the physical experience of being in the garden – of damp shade, filtering light, and fragrant air – through the suggestive variation of tone on surface. In these canvases, the temporal conditions that characterized the individual works in previous series have vanished. Eternal summer prevails in the water garden. In lieu of shifting time and season, Monet experimented with subtle shifts in his point of view. By moving his easel a bit to the left or right, he altered the borders of the grassy banks. Similar variations in the level of his view raised or lowered the surface of the pond. Even the one stable element – the Japanese bridge – was moved skyward, and in one image, the curving blue bands of the bridge were suspended near the top of the canvas like a canopy arcing over the rafts of lilies that shine like sheets of mother-of-pearl (see pages 62–63).

When the weather turned cold, Monet took his canvases into the studio, completing six to his satisfaction in the early days of 1900. In February, he departed for London, leaving his gardener with a detailed list of instructions to carry out in the months ahead. He remained abroad until April, working on three distinct subjects: *Waterloo Bridge, Charing Cross Bridge,* and *Houses of Parliament*. As in previous series set in specific locations, Monet allowed

the time of day to dictate the desired effect. But in the London pictures of 1900, the atmosphere and light coalesced in an unprecedented manner, so that the physical sensation of the surrounding air – whether brilliant sun or impenetrable fog – far supersedes the chosen subject.

In April 1900, Monet returned to Giverny, and, in the months that followed, he turned his undivided attention back to the water garden. He completed the six canvases that remained from the year before and, over the summer, added six more works to the series. The new paintings presented changes in form, colour, and point of view. Monet's brush stroke – crisp in the 1899 paintings – loosened, emphasizing calligraphic description over sparkling definition. He chose more vivid, exuberant hues, introducing reds and violets where only the most delicate pinks had prevailed. He focused his attention on the left bank, moving only slightly from canvas to canvas, and he set the bridge as a stable element, arcing just above the centre of the canvas and spanning the right side of the composition. More lush than before, the heavily laden branches of the trees and the massed flowers and grasses on the bank suggest the inherent vitality of the natural world. As with his previous series work, Monet immersed himself in the visual experience of the moment before him, but it was nature's power of self-renewal, rather than the passage of time and the seasons, that inspired Monet to search for what was timeless within the context of temporality.

In November 1900, Durand-Ruel presented another solo exhibition of Monet's work in his Paris gallery, featuring twelve paintings of the Japanese Bridge. The critics found it difficult to comprehend this new and startling direction in Monet's work, and many attempted to understand it in relation to a Japanese aesthetic. For some, Monet's set of images fell short of their presumed Japanese models; he was criticized by one critic for concentrating too exclusively on such a restricted vista. Others noted that he was much more successful with his Western subjects: *Grainstacks, Poplars,* and *Rouen Cathedral.* But, writing in *La Chronique des Arts,* Julien Leclercq praised Monet for his consistency in his point of view, noting that his work surpassed the Japanese in its vitality, variety, and command of naturalism.

This debate mattered little to Monet. His study of Japanese art had led him to strive for the deep, instinctive relationship that he believed was the foundation of their landscape tradition rather than simply emulate its serene beauty. For Monet, his paintings of the Japanese bridge were part of an evolving series of revelations. Leclercq seemed to sense that the paintings represented the unfolding of an idea, and he predicted, "We will understand [them] one day better than we do now."

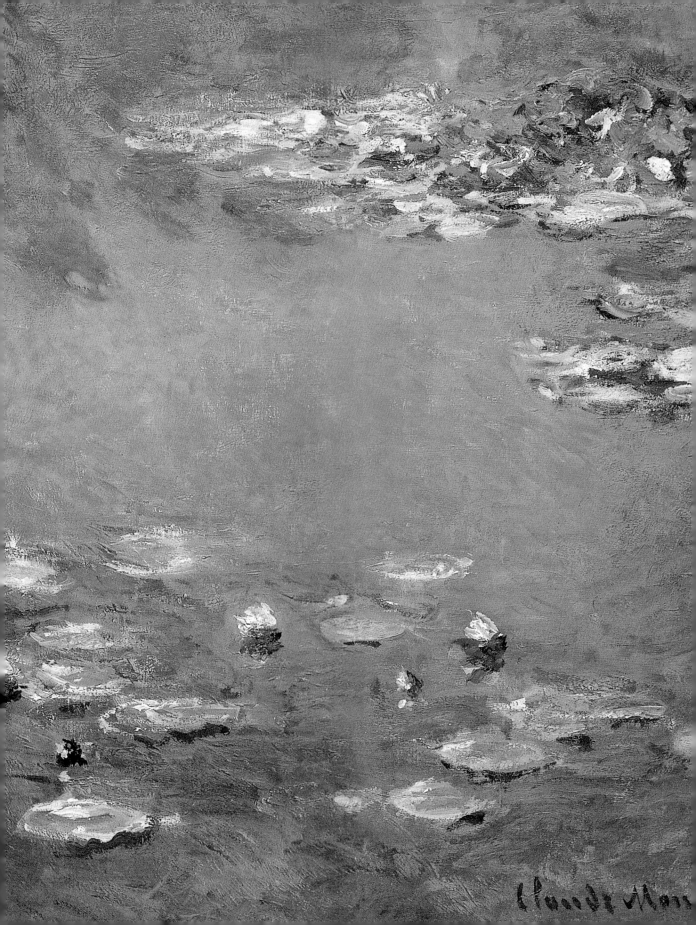

Chapter 4
LANDSCAPES OF WATER

While the presence of the *Japanese Bridge* series of paintings in Monet's solo exhibition at the Galerie Durand-Ruel in 1900 drew a very mixed reception from the critics, the intriguing image of Monet's ethereal garden stirred the curiosity of the public. Increasingly, journalists ventured from Paris to Giverny to try to interview the famously reticent artist, hoping also to get a glimpse of the fabled pond to share with their readers. One critic, Arsène Alexandre made the journey in the summer of 1901 and published his account in the 9 August edition of *Le Figaro*. Alexandre had, in fact, been among the critics who had questioned the intimate and insular nature of Monet's new paintings. Previously he had endorsed Monet's work without reservation, but the motifs of the *Japanese Bridge* series struck him as "a bit simple and of secondary interest." When he visited the artist at Giverny, Alexandre changed his opinion. He summed it up for his readers by noting that along with the conventional wisdom that "A man is known by the company he keeps," he now believed that "You cannot claim to know a man until you have seen his garden."

In his article, entitled "Monet's Garden," Alexandre took his readers on the picturesque rail journey from Paris to Vernon. He described Giverny as pretty but "somewhat characterless" until the traveller's eye was arrested by the sight of an "extraordinary pageant" displaying "every colour of a palette, all the tones of a fanfare." This, Alexandre explained, was Monet's flower garden. He cautioned that the artist guarded his privacy: "There is a gate! ... and it is not always open." Only the fortunate few who were invited in experienced the full delight of the "floral fireworks," arranged in profusion by "a great colourist."

Water Lilies (detail), 1906

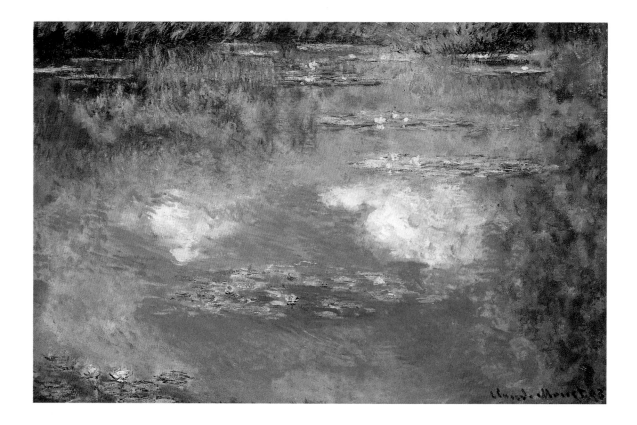

If the flower garden delighted the visitor with its vitality, the water garden enchanted with its aura of mystery. Alexandre compared the embellishment of the ornamental pond to rare and exotic craftsmanship, "damascened as it is with the water lilies' great round leaves, and encrusted with the precious stones of their flowers – the masterwork of a goldsmith who has melded alloys of the most magical metals." The subtle sensations of the water garden revealed to Alexandre the great depth of Monet's latest paintings, and he openly admitted that "it was useful to see the painter's garden, in order to truly understand his work."

Even the painter seemed transformed in this environment. After knowing Monet for two decades as "somewhat laconic and cold in Paris," Alexandre was surprised to see that the painter "glows with benevolence" among his flowers. The critic confessed that although he had long admired Monet's art, only now had he come to comprehend the full power of the painter who had "dared to create effects so true-to-life as to appear unreal." In cultivating his garden, Monet pursued his art; it was his constant source of inspiration. Both mentor and model, the painter's garden served as the touchstone for his artistic endeavours.

Water Lily Pond (*The Clouds*), 1903, private collection.
In his *Nymphéas* series, Monet explored the two motifs that had long intrigued him: water and the elusive quality of reflection. Here, the water's surface mirrors the swaying foliage and the clustering clouds that hover above the pond. The water flows across the breadth of the composition; only a fringe of foliage at the top anchors the pond to its surrounding banks.

But, at the time of Alexandre's visit, Monet had not set up his easel in his water garden for more than a year. After completing the series on the *Japanese Bridge,* he spent the late summer and early autumn months of 1900 in Vétheuil, painting views of the river. In February 1901, Monet left Giverny to work in London, taking up the subjects he had discovered in the previous year: the Houses of Parliament, Waterloo Bridge, and Charing Cross Bridge. He also took his easel out that winter into Leicester Square, but his robust health was waning with age. Early in April, a severe bout of pleurisy forced him to cut short his stay in London and return to convalesce in Giverny.

While painting in London and Vétheuil, Monet's primary concerns were the palpable qualities of the atmosphere and the variable effects of stable images, such as the houses along the river, reflected on the water. The *Japanese Bridge* series had presented similar challenges, but in the context of this new work, Monet had begun to recognize the limitations, as well as the potential, of his water garden. The pond was small and planted to capacity. When the lilies were in full bloom, they carpeted the surface, blocking the random accidents of reflection. There were few places on the narrow banks where Monet could comfortably set up his easel, and in the *Japanese Bridge* series, he had fully explored the most advantageous point of view.

A GRANDER VISION

On 10 May 1901, Monet purchased the strip of meadowland that bordered his garden to the south just beyond the Ru. Over the summer he consulted with engineers to draw up plans to triple the surface area of his pond and to, once again, reroute the river. When Alexandre came to visit that summer, he was unaware that the little pool with its "marquetry of great full-blooming flowers," was about to be subsumed into a grander vision.

In December, Monet obtained permission for his plans from the local *préfet* and the town council, and by the early months of 1902, the excavations for the enlarged pond were underway. In March, the workmen left and the gardeners began the second stage of the garden's transformation. New bushes, dozens of ferns, stands of bamboo, and ornamental trees were spread over the expanded acreage, while irises, grasses, agapanthus, and weeping willows were densely planted to frame the pond. Four additional footbridges were built to allow access across the new route of the Ru and the original Japanese bridge was capped with a trellis to carry wisteria. Monet had another trellis erected to block the view of the railroad that ran through his property; he planned to cover it with climbing roses.

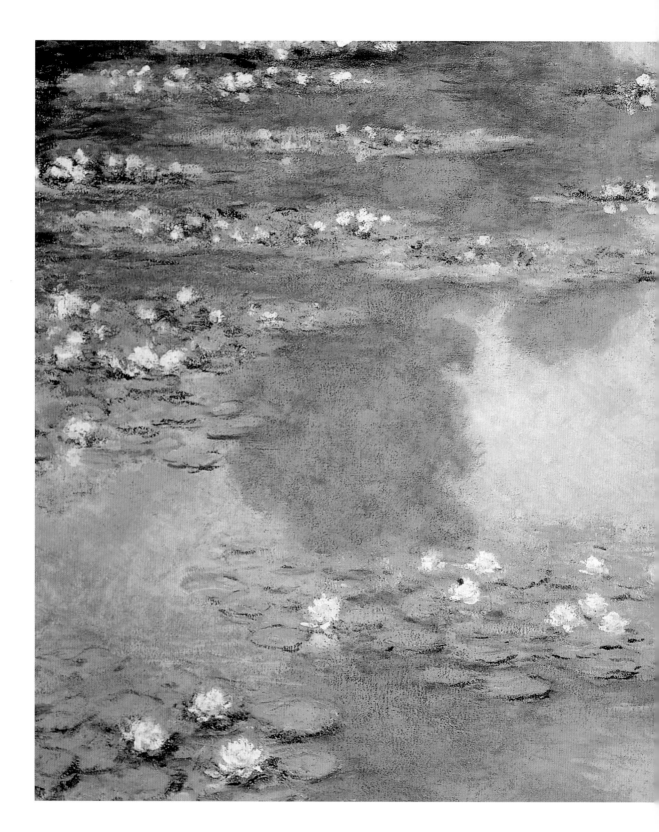

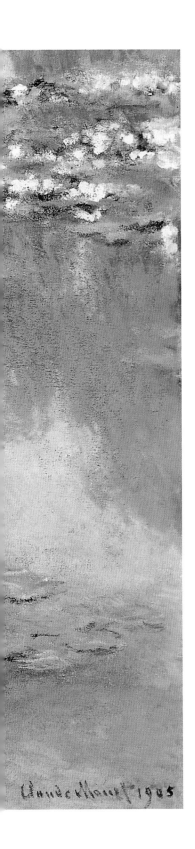

Persistent frost that spring caused Monet unending worry and delayed the sowing of a new selection of lilies, with colours ranging from the delicate tints of pink, white, and yellow to vibrant shades of red, copper, and turquoise. At one point, Monet feared that he had undertaken too vast a change, writing to Alice, who was in Brittany helping her eldest son recuperate from an illness, "I'm over my head with this pond." But Monet forged on and created the garden that would satisfy his aesthetic vision. "I have always loved sky and water, leaves and flowers," he observed in retrospect. "I found them in abundance in my little pool."

A DARING INNOVATION

During the summer of 1902, as his reconfigured water garden came into its first bloom, Monet painted his flower garden, concentrating on the abundant spread of blossoms along the Grande Allée (see pages 48–49). But there is evidence that he was already planning a series of paintings – perhaps making preliminary studies – that marked a daring innovation inspired by the broader surface of the pool.

At Christmas that year, the painter Mary Cassatt wrote to her friend Louisine Havemeyer, a prominent American collector: "Monet is painting a series of views [just] reflections in water, you see nothing but reflection!" Cassatt did not see these paintings; she was sharing with Havemeyer news she had heard from the critic Roger Marx. No paintings have been dated to that summer. But Monet's long-standing belief in careful observation as a prelude to painting – as well as his habit of finishing *plein-air* pictures in the studio when the weather did not permit working on the spot – suggest that his imaginative engagement with the motif that would fascinate him for the rest of

Water Lilies, 1905, Museum of Fine Arts, Boston.
The diffused silhouettes of the leafy trees reflected on the water in the compositions of 1905 reveal that Monet studied his pond from a single point of view. He painted the lilies as they glided across the glimmering waters, their delicate tones of green and pink marking the extreme refinement of his palette. All references to the surrounding terrain have disappeared; the landscape is exclusively water.

his life began during that summer. He would look back at this moment with amusement: "I became infatuated with light and reflection. And there you have it, the way in which I ruined my career."

Monet's paintings of the summer of 1903 reveal the daring concept that Cassatt mentioned to Havemeyer (see page 72). Each composition presents a glance across the shimmering surface of the pond. In an unprecedented burst of freedom, Monet released his subject from the moorings of its surrounding terrain. He preserved only a few details of the pond's setting, as seen in the fringe of foliage which caps the top of one canvas or the overhanging veil of willow branches that appears in the others. It was the water that now riveted Monet's attention. Through his motifs – the floating lilies and their reflections – he explored the innate qualities of water that fascinated him: its subtle movement and the way it mirrored image and light.

Monet also discarded the scintillating brush stroke and the exuberant palette he had used to paint the Japanese bridge. His new vision of the pond featured a smooth, even brush stroke, suggesting the gentle movement of the water's surface, and a refined range of cool, crisp colour that captured the subtle play of light. Across the boundless plane of the luminous pond, the lilies chart a random path, sometimes clustering together, their flat pads seeming to merge into a single raft of leaves, which then jostles apart according to the whim of the water. The blossoms sparkle in dabs of pure pigment against the more subtle tones of their foliage.

But the lilies are only part of the visual experience. When, in 1897, Monet first attempted to paint the floating lilies, he isolated them, focusing upon the effect of the blossoms bursting into bright colour against the muted tones of the pads and the water (see page 57). For the new paintings Monet allowed his gaze to skim over the pond, understanding the floating forms as part of a broader ensemble. Like the reflections of the trees and

Water Lilies, 1906, Art Institute of Chicago.
Patient observation had taught Monet to study every nuance of nature. Here, pale pink lilies scatter among green pads in the foreground (see detail on page 70). Above them, individual pads float together to make unstable rafts. But for Monet, the lilies were "just the accompaniment." He explained, "The essence of every motif is the mirror of water whose appearance alters at every moment."

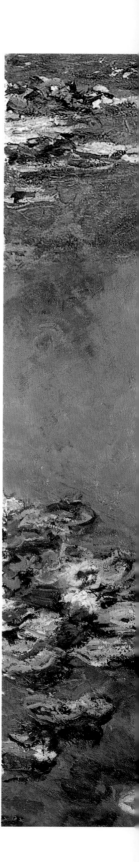

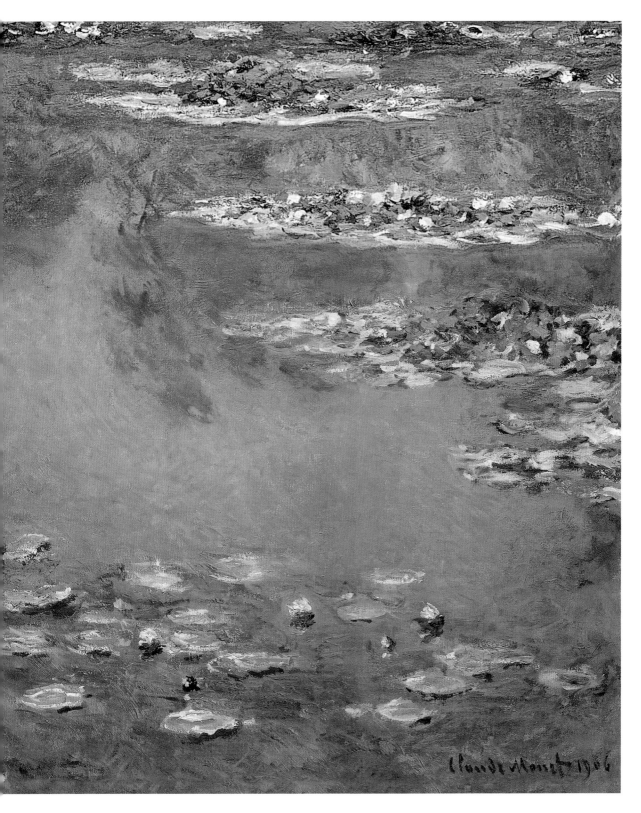

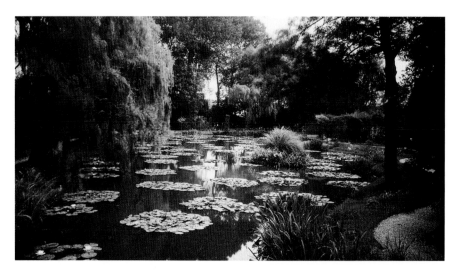

LEFT *View of the Water Lily Pond and the Japanese Bridge*, c. 1905, private collection. In 1901, Monet redesigned his water garden, expanding the pond surface to triple its size. The original span of the pond was not much wider than a stream, inhibiting the free flow of the water lilies. The increased width and breadth allowed the lilies to float and cluster at random. Like colourful rafts, they slide across the glassy waters, over the reflections of the trees planted along the banks.

RIGHT *Nymphéas, Water Landscape*, 1907, Wadsworth Atheneum, Hartford, Connecticut. Late in the series, Monet concentrated on two light effects: the bright, suffused glow of the morning and the dramatic, isolated illumination of the evening. Painted in the pale morning sun, this canvas explores the relationship of two tones in luminous reflections and a surface that shimmers with warm light. Critics applauded his daring innovations as "the final degree of abstraction and imagination allied to the real" in landscape painting.

foliage bordering the bank and the clouds that drift above in the sky, the depiction of the lilies, always in motion, intrigued Monet for what they revealed about the nature of water.

Monet returned to paint beside his pond the next summer. He continued to focus upon the pond's surface, watching for the subtle shifts in the position of the lilies and the forms reflected in the water. But the paintings of 1904 feature a more acute perspective than those of the previous year, as if Monet's glance had travelled swiftly up, rather than slowly along, the surface of the water. He also expanded the presence of the grassy bank at the upper edge of the composition, as if gently to counter the slow but ceaseless motion rising upward from the bottom of the canvas. The lily pads are more densely clustered than before, massed into elongated ovals of light-struck greens or opalescent shades of pale grey and blue. Dabbed on in bright spots of pure pigment, the blossoms rise above them. Reflections shimmer on the water beneath, softer in form and more muted in tones of violet, rose, and lavender. This layering of imagery – the vivid flowers on the light-saturated leaves, over the diffused reflections – increased the surface richness and translucence. With a keen eye and an expressive brush, Monet followed every nuance of the subtle interplay of light and motion before him. He recognized the possibilities of his pond to be infinite. "The essence of every motif," he said, "is the mirror of water whose appearance alters at every moment, thanks to the patches of sky which are reflected in it, and which is its light and its movement."

In 1905, Monet briefly returned to the motif of the Japanese Bridge. The enlarged water garden allowed him to increase the distance from his

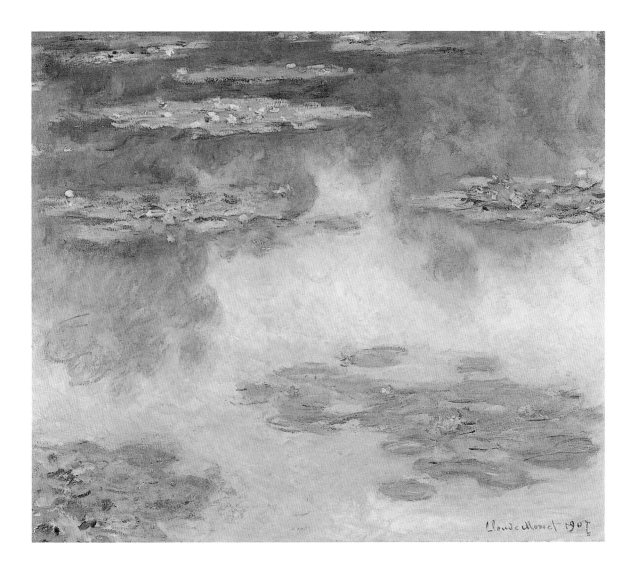

easel to the bridge, and for each of the three canvases he painted of it that summer, he chose a noticeably different point of view. After his controlled concentration on the pond's surface, these paintings provided a panoramic vista, as if the artist was stepping back to reassess the whole of the garden.

He also relaxed the elegance of touch he had cultivated in the past two years, working instead with a calligraphic freedom and an energetic exuberance of stroke and colour which was reminiscent of the paintings of 1900. But this departure marked only a brief pause, rather than a change of direction. He continued his work through the summer by gazing back into his pond to paint its expanse of floating lilies and glistening reflections.

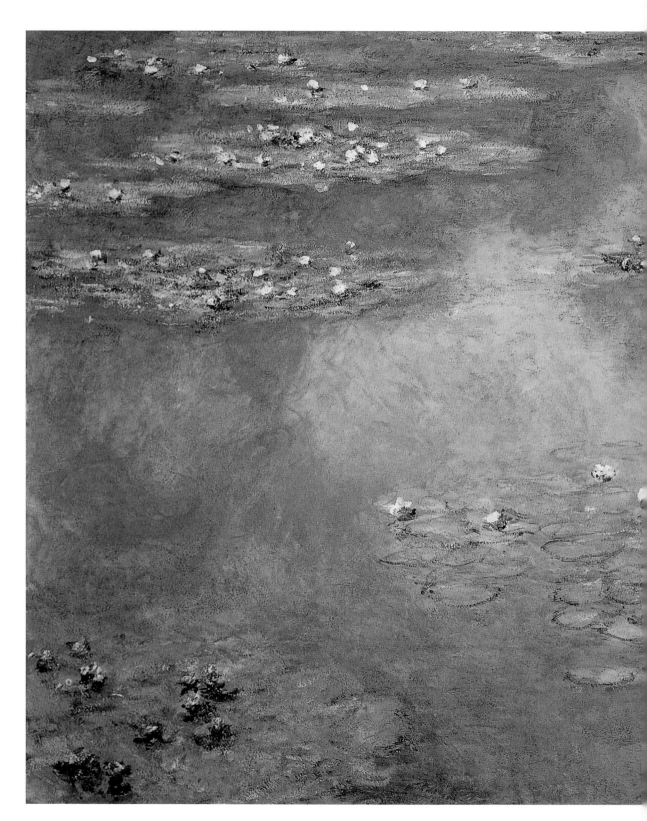

AN UNPRECEDENTED DELICACY

For most of the water lily paintings of 1905, Monet selected a square canvas. The reflective surface now flowed from edge to edge, top to bottom, unencumbered by any intrusion of the pond's banks. He reasserted the refinement of the previous paintings in the series, achieving an unprecedented delicacy. The lilies appeared on the glassy surface like floating jewels, while the shimmering reflections became softer and more amorphous. But over the summer, he loosened his stroke again, working in warmer, richer tones, such as rose and yellow, on a rectangular canvas. Later that year, the journalist Louis Vauxcelles came to Giverny to interview the artist in his studio. Although Monet explained his method of working in series through reference to his London paintings, the canvases that Vauxcelles saw gave the critic greater insight: "Claude Monet paints the same picture many times, and never – this became clear as we were looking at the dazzling *Water Lilies* – never is there the slightest trace of fatigue."

Over the years, painting in series had taught Monet the value of tireless and persistent observation. In 1886, working in Belle Isle on the rugged coast of Brittany, Monet declared, "I know very well that to really paint the sea one must observe it every day at every hour and from the same place." But the method he chose had inherent frustrations for an artist dedicated to capturing the fleetness of the visual experience. While working on the series of *Grainstacks* in October 1890, Monet wrote to his friend Geoffroy that he felt hampered by his deepening understanding of the complex volatility of light and atmosphere, that his brush could not move fast enough to keep pace with what was happening before his eyes: "I'm becoming so slow in my work that it makes me despair, but the further I go, the better I see that it takes a great deal of work to succeed in rendering what I want to render: 'instantaneity.'"

Water Lilies, 1907, Museum of Fine Arts, Boston.
By working in series, Monet sought to capture the visual effects of a single moment, preserving the fleeting experience of light and atmosphere in paint on canvas. In conversation with the critic Roger Marx, Monet described himself as "a hypersensitive reactor," able to "project on a canvas, as if on a screen, impressions registered on my retina."

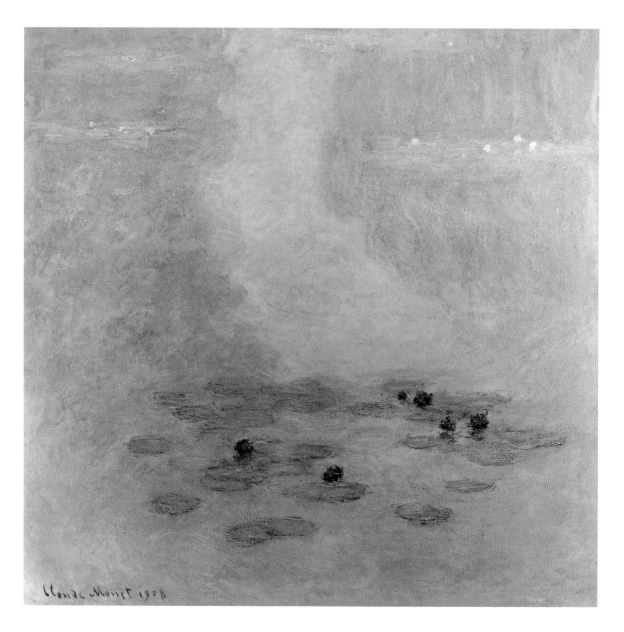

Now, fifteen years later in his water garden, Monet was able to bring into balance the two opposing forces that fuelled his art: the mutability of nature and his desire to respond to this process of infinite change in the static medium of painting. To attain his objectives in 1906, he began to focus upon a single location on the surface of the pond, watching for the most subtle variations of tone, light, shadow, as well as the movements of the lilies on the water. Alice's letters to her daughter Germaine that summer reveal that Monet agonized over the instability of the weather and his own inability to keep pace

Water Lilies, 1908, private collection.
Late in the series, Monet studied the waning illumination on his pond in the evening as the sun was setting. The paint appears to have been washed over the surface of the canvas in a light-struck haze, melding the flowers, the water, and the muted reflections into a single luminous vision.

with the changing appearance of his pond. Still, his pursuit of his subject was relentless. On 12 August, as the season for the lilies drew near its end Alice wrote, "Monet is working like a madman and much too much." But, at the end of the year, he seemed satisfied with his work, informing Durand-Ruel that he would be ready to exhibit his new paintings in the spring.

Early in April 1907, only two weeks after he had confirmed the date for the exhibition with Durand-Ruel, Monet changed his mind and asked his dealer to release him from their agreement. In a letter of 27 April, Monet expressed his regret, explaining that little in the series was "satisfactory enough to trouble the public with." While he admitted that "Perhaps it's true that I'm very hard on myself," he was firm in his belief that only five or six of the works he had done to date were worthy of exhibition. Monet also confessed to having destroyed thirty of the paintings that displeased him, explaining that "as time goes by I come to appreciate more clearly which paintings are good and which should be discarded." He dismissed any possibility of releasing a small selection of the paintings for exhibition, stating, "the whole effect can only be achieved from an exhibition of the entire group," and said that he needed "to have finished pictures to compare with what I'm doing." Monet assured his dealer that his current dissatisfaction did not deter his plans for the series; he was eager to continue and confident that his work would improve. But he stopped short of scheduling a future exhibition.

A RIGOROUS SCHEDULE

Freed from his commitment, Monet returned to his series with renewed intensity. He followed a rigorous schedule, setting his easel up at the pond in the first light of the morning and working through the early afternoon, stopping only briefly for lunch. Later in the afternoon, usually around three o'clock, when the light was the most volatile and the lilies began to close, he took a break for two or three hours, to rest and receive visitors. Monet often returned to the pond in the evening to study the effects of the fading light.

As in the previous year, Monet continued to focus upon a single view of the pond's surface, sharpening his response to the nuances of tone created through subtle shifts of illumination. He experimented with a variety of formats, returning to the square canvases and then exploring the more decorative form of the circle. By the end of the summer, he switched to a rectangular format with a vertical orientation, which made the lilies appear as if they were floating down the surface of the canvas – gliding on a stream of light. Visiting in December to discuss the possibility for an upcoming

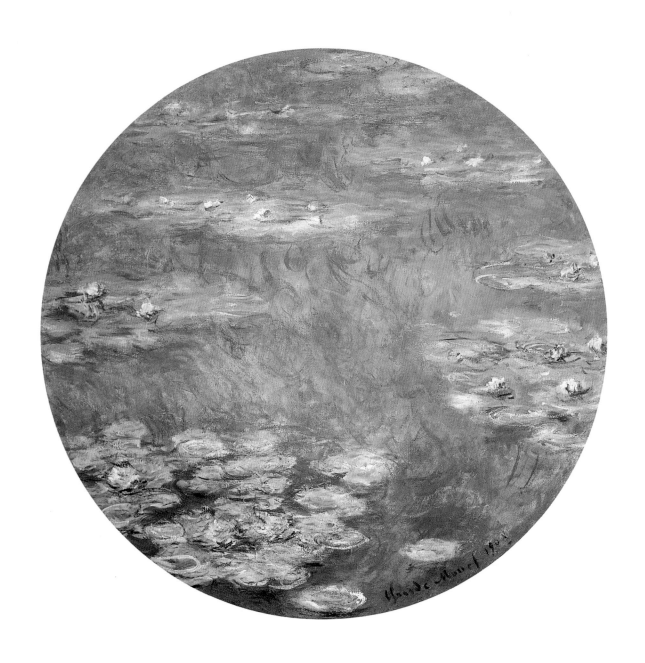

Water Lilies, 1908, Dallas Museum of Art. Through the course of the *Nymphéas* series, Monet experimented with different compositional formats. The circular canvas emphasized the decorative aspect of the subject, conveying what he described as "the illusion of an endless whole, of water without horizon or shore." Using feathery brush strokes to describe the lilies and their opalescent pads, Monet attained the effect of the aquatic plants skimming across boundless waters.

exhibition in May 1908, Durand-Ruel was astonished at the progress Monet had made. But he warned Monet that these new paintings, with their radical departure from the conventional world of representation into a pure realm of light, form, and colour, would be extremely difficult to sell. Monet did not hide his anger at his dealer's response and threatened to cancel the proposed exhibition. In a letter of 20 March 1908, he blamed his ongoing frustration with the series on Durand-Ruel's lack of support: "From the moment that my new paintings did not meet with your complete approval, it appeared to me that it was going to be difficult for you to mount the exhibition."

By the end of April, contrite and with waning confidence, Monet admitted to Durand-Ruel that he could not think of being ready to exhibit his works in May: "I am at the end of my tether and would end up being ill if I were going to continue with [this] impossible undertaking." Monet's health, as well as his spirits, showed signs of strain. He suffered dizzy spells and blurred vision. Alice attributed his symptoms to anxiety and agreed with Durand-Ruel that Monet needed to take his mind off the series and rest.

As the date of the exhibition approached, shocking news about the artist reached the public. The 16 May edition of the *Washington Post* printed the headlines: "IMPRESSIONIST MASTER ON EVE OF EXHIBITION RUINS HIS NEW PICTURES. CRITICS PRAISED THEM." Four days later, a story in London's *Evening Standard* confirmed the story, but cautioned that the extent of the damage was exaggerated. The reporter noted that Monet had been engaged in a revolutionary project – "one which, I believe that no other artist has developed – the painting of clouds on water" – and that by early spring more than thirty canvases were near completion. But in recent months the artist had become discouraged, first requesting that the exhibition be postponed and then demanding that it be cancelled. "Partly because of overstrain, partly because of dissatisfaction, M. Monet became extremely irritable and morose, and at last actually cut a few of his canvases to shreds." The article reassured readers that the majority of works survived, turned to the wall on the recommendation of "conscientious friends."

By the end of June, Monet was back at work, determined at last to comprehend the elusive beauty of nature through the paint he applied to his canvas. Throughout the summer he worked with unrelenting intensity, often refusing to see visitors or take his afternoon rest. On 11 August he wrote to his old friend Geoffroy, "These landscapes of water and reflections have become an obsession. It is beyond my old man's powers and I want nonetheless to succeed in rendering what I feel. I destroy some of them . . . I start them over again . . . and I hope that with so many efforts something will emerge."

By the end of September, as the weather turned harsh, Alice was finally able to persuade Monet to put down his brushes. Late in the month they left Giverny for a ten-week stay in Venice, where Monet relaxed and then painted the buildings along the Grand Canal. He returned invigorated, and, after negotiating a deal with the Bernheim-Jeune Gallery for the canvases completed in Venice, he turned his full attention to studio work, putting the final touches on his most recent water lilies. On 28 January 1909, Monet instructed Durand-Ruel to schedule the opening of the long-awaited exhibition for 5 May, assuring his ever-patient dealer, "I will be ready."

Monet took an active role in the exhibition arrangements. He had specific demands for the installation, requesting that the canvases be arranged in the gallery in the order that they were painted, beginning with a single example from the *Japanese Bridge* series of 1900. The catalogue also featured a chronological listing; each of the forty-eight new works were given the same title — *Water Lilies* — so only the year distinguished them. Monet wanted to simulate his experience of painting the pond for his viewers, presenting the paintings not as individual images but in succession, as a sequence of observations that gain meaning through their totality. Durand-Ruel suggested that the exhibition be titled *Réflexions,* drawing attention to what he regarded as the most innovative and eye-catching motif. But Monet preferred *Les Nymphéas: Series de paysages d'eau (The Water Lilies: Landscapes of Water),* defining through his title both the subject and the essence of his work.

Concerned that Monet had not presented new works to the public since 1904 when his London views were on exhibition, Durand-Ruel arranged for some advance publicity. Although Monet was reluctant, he allowed a young writer named Jean Morgan to view the works at Giverny before they were sent to Paris. In an article that appeared in *Le Gaulois* one day in advance of the opening, Morgan announced to his readers that Monet's upcoming exhibition would reveal "an unforeseen application of his qualities." Through the pursuit of a narrowly defined subject, Monet had strengthened his powers of observation and refined the focus of his expression to an uncanny degree.

CRITICAL ACCLAIM

When the exhibition opened, the critics were not disappointed. The *Nymphéas* series received unanimous critical acclaim. Roger Marx, in a long article published in the *Gazette des Beaux-Arts,* cited the element that the critics found most daring. In the course of painting his *Nymphéas,* Monet had freed landscape from its terrestrial anchor: "No more earth,

no more sky, no limits now; the dormant and fertile waters completely cover the field of the canvas, light overflows, cheerfully plays on a surface of verdigris leaves . . . Here the painter deliberately broke away from the teachings of Western tradition by not seeking pyramidal lines or a single point of focus." But, as Marx noted, the artist bristled at being labelled a visionary. In a long extract from a conversation with the artist, Marx allowed Monet to speak for himself: "You mustn't assume that I have labyrinthine, visionary plans. The truth is simpler; the only virtue in me is my submission to instinct; it is because I have rediscovered and allowed intuitive and secret forces to predominate that I was able to identify with creation and become absorbed in it."

Monet cites his love of the natural world as the source of his inspiration and the strength of his art: "I have no other wish than to mingle more closely with nature, and I aspire to no other destiny than to work and live in harmony with her laws." But Marx countered that the subjective wonders of nature were only revealed through human endeavour, "the thought that defines it…the poetry that sings her praises…the art that portrays her." And in recognizing and celebrating the beauty of nature, Monet had given the world new insight: "Never in all the years since mankind has existed and men have painted, has any one painted better or quite like this." The *Nymphéas* series was a testament to Monet's enduring desire to ally his art with nature; by releasing his painting from all conventional expectations he found the means to express the revelations of his pond.

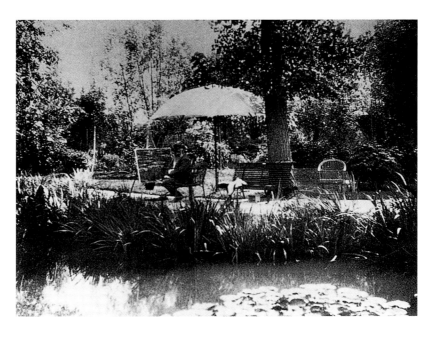

Chapter 5
FRIENDS AND FOLLOWERS

In April 1886, the exhibition titled *Works in Oil and Pastel by the Impressionists of Paris* opened to record crowds at the American Art Gallery in New York City. Organized by Durand-Ruel, it featured forty works by Monet, including *Meadow with Haystacks Near Giverny*. At the time, few of the gallery patrons had ever heard of the small Normandy village where Monet pursued his art and cultivated his garden. But in the following year, readers of the October 1887 issue of the American journal *Art Amateur* learned that Giverny had become an attractive destination for aspiring painters. Writing under the pseudonym "Greta," the Boston correspondent noted: "Quite an American colony has gathered, I am told, at Giverny, seventy *[sic]* miles from Paris on the Seine, the home of Claude Monet." According to "Greta," paintings from this newly formed circle reflected the influence of the Impressionist master. "Pictures just received from these men show that they have got the blue-green colour of Monet's impressionism and 'got it bad.' "

When Monet first moved to Giverny in 1883, he confessed to Durand-Ruel: "I think I've made a terrible mistake in settling down so far away [from Paris]. I'm totally disheartened." But surrounded by his family in an environment that proved to be a constant stimulus to his imagination, Monet's doubts rapidly disappeared. Whenever he felt cut off from the art world, he made the journey to Paris, and he urged his friends and colleagues to visit him in Giverny. Within a decade of moving to his new home, he even tried to persuade his former Impressionist colleagues to abandon their informal monthly meetings at the Café Riche in Paris and come to Giverny instead. For Monet, urban life had lost its appeal: "How

Frederick Carl
Frieseke, *Lilies* (detail)

can one live in Paris? It's hell. I prefer my flowers and this hill that surrounds the Seine to all your noises and nocturnal lights."

A PAINTER'S PARADISE

Monet had never expected that a group of American artists would also find inspiration in Giverny. Always very cautious in social situations and highly protective of his work and his family, he attempted to keep the newcomers at a distance. But it was inevitable that the paths of the American painters and the French master would cross, with surprising results. Although Monet believed that art could not be taught, he became the unwitting mentor of the artists who gathered at Giverny. Over the years, only a few of these artists were drawn into Monet's circle of friends and family, but his influence on the others was undeniable. Over three decades, the tiny and once obscure village of Giverny was transformed into a painters' paradise, with Monet presiding behind a locked garden gate.

Although Giverny was farther from Paris than Argenteuil, Monet hoped to revive his friends' practice of making the trip to visit with him and paint together out of doors. Caillebotte took advantage of this invitation, as did

John Singer Sargent, *Claude Monet Painting at the Edge of a Wood*, 1885, Tate, London.
During Sargent's first visit to Giverny, Monet took him out to paint in the open air. Although he had earned his fame as a society portraitist, Sargent had become intrigued with *plein-air* painting. Here, his loose brush stroke reveals his quick and spontaneous response to the subject before him. But his palette, employing strong light and dark contrasts, lacks the fresh sparkle that distinguished Monet's presentation of figures in natural settings.

Cézanne and Renoir. The first American painter to join Monet at Giverny came as an invited guest and had no connection to the burgeoning art colony in the village. John Singer Sargent may have first met Monet in 1876 at the second Impressionist exhibition, but their mutual friendship only developed a decade later.

Born in Florence and schooled in Paris, Sargent was a true cosmopolitan, moving easily among art circles in England, Italy, and France. In 1884, after the exhibition of his scandalous portrait of the "professional beauty" Madame Pierre Gautreau, identified only as Madame X, Sargent retreated from his critics in Paris and spent a summer at the artists' colony in the village of Broadway in Wiltshire, England, painting the landscape and working out of doors. In the following year, he was delighted to join Monet in Giverny, eager to expand his experience painting *en plein air.*

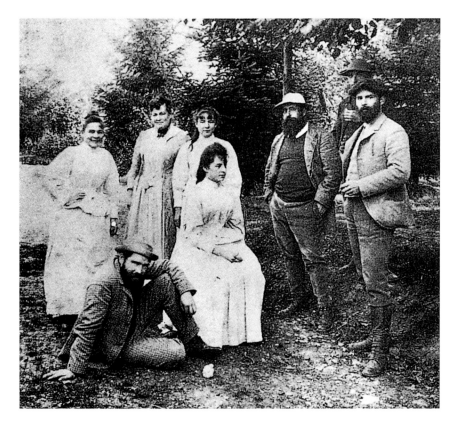

LEFT John Leslie Breck, *Garden at Giverny*, c. 1890, Terra Museum of American Art, Chicago. Breck readily adopted the motifs painted by Monet, hoping to acquire a more responsive touch and palette through the challenge of painting natural subjects. Here, his use of pure colour and light brush strokes show his full assimilation of this new approach. In his first solo exhibition in Boston, he included six garden paintings, most from various locales in Giverny, and at least one of Monet's own garden.

RIGHT *John Leslie Breck in Monet's Garden at Giverny*, 1887, private collection. Although many American painters were inspired to take up temporary residence in Giverny, few were welcomed into Monet's domestic circle. Seated in the foreground, Breck is seen here with Monet and his family. On the left, Alice is flanked by her daughters Blanche and Germaine, with Suzanne on a chair before them. Monet stands at Suzanne's left, his son Jean is behind him, and the American painter Henry Fitch Taylor is on the right.

Sargent returned almost annually, making his last visit to Giverny in the late spring of 1891.

Sargent painted Monet and Alice during his first visit in 1885. The canvas, *Claude Monet Painting at the Edge of the Wood* (see pages 90–91), recalls the portraits by Renoir and Manet of Monet's young family, painted a decade earlier in Argenteuil (see page 26). While Monet works at a low easel on a recognizable painting – it has been identified as *Meadow with Haystacks at Giverny* of 1885 – Alice sits nearby, engrossed in her reading. There is a companionable air of informality, not simply between the artist and his wife, but between Sargent and his subject. Although Sargent was known for elegant society portraiture, characterized by a rich, deep palette and a bravura brush stroke, here he used a more modest range of tones. His quick, descriptive touch was, perhaps, in emulation of Monet's own innovative style.

Long after this initial visit, Monet shared an anecdote about Sargent with the dealer René Gimpel. When Monet suggested that he and Sargent go out of doors to paint, Sargent protested, claiming that he had not brought his supplies. Monet gave him a canvas, an easel, palette, and paints, but when

Sargent saw the colour selection, he noted that black was not included. When he asked Monet for the missing pigment, Monet replied that he did not keep it on hand, to which Sargent supposedly exclaimed, "Then I can't paint. How do you do it?" Although Sargent's portrait *Claude Monet Painting at the Edge of a Wood* falls short of the sparkling freshness of colour Monet achieved *en plein air,* it demonstrates a sense of spontaneity unequalled in his studio work. Although Monet did not record a response to Sargent's painting, it is clear that he admired the American's ability. He owned several paintings by Sargent, which he hung in his bedroom with other canvases painted by friends. Two years later, Monet painted Alice's daughters Suzanne and Blanche in the woods (see page 97) in a composition reminiscent of the one painted by Sargent.

Other American painters made visits to Giverny before the colony began to form. Willard Metcalf, a landscape and figure painter, collected bird's eggs, and an entry in his collecting diary identifies a blackbird's egg as found in Giverny in May 1885. He returned the following June. On that trip he added more eggs to his collection, but he claimed as well that Monet invited him to lunch, and then they spent the afternoon with Blanche, painting in the flower garden. Theodore Robinson also made his initial visit to Giverny in 1885, when he was escorted to Monet's home by a mutual friend, the landscape painter Ferdinand Deconchy.

In the summer of 1887, Metcalf and his friend Louis Ritter set out on a walking tour of the Seine valley. It was common practice for art students enrolled in the Parisian academies, particularly those from other nations in temporary residence, to summer in picturesque locations, where they could continue to paint when classes were not in session. At the time, Brittany, with its rugged landscape and distinctive regional culture, was the most popular destination, and lively art colonies could be found in Pont-Aven and Concarneau. Metcalf and Ritter made the decision to explore the Seine valley after a visit with their friend, the painter Paul Coquand, who lived in the district of Eure. According to the musician Edward Breck, who joined the colony with his brother John Leslie Breck and their mother, the two painters were astonished by the beauty of the region that became more varied and verdant as they approached the Seine. But nothing matched what they saw in Giverny. In Breck's words, "the transcendent loveliness of the country cast a spell over them, and they wrote to their friends in Paris that Paradise was found and only waiting to be enjoyed."

Theodore Robinson, Theodore Wendell, and William Blair Bruce, as well as the Breck brothers, were the first to join Metcalf and Ritter. All but

John Leslie Breck, *Garden at Giverny (In Monet's Garden)* (detail), *c.* 1887, Terra Museum of American Art, Chicago. Breck's interest in flower subjects grew directly from his emulation of Monet's style and motifs. This canvas was painted late in his first summer at Giverny. The towering roses are in full bloom, and on the left side of the path, sunflowers push up through the dense foliage. Breck applied his high-toned colour in quick, spontaneous strokes, capturing the ephemeral beauty of the garden in full flower (see detail right).

Bruce, a Canadian, hailed from the United States, and, in retrospect, Breck defined this little art colony as "the 'simon pure' original 'Givernyites.' " Others followed, including the English painter Dawson Dawson-Watson, who later claimed that the painters were not aware that Monet had a home in Giverny. Breck made a similar assertion in his account, stating that "Hardly had the little company begun to transfer the lovely motifs of the neighborhood to their canvases when they discovered that they were not the only painters in Giverny, that none other than Moret [sic] himself had already been living there for several years past." And, according to Breck, none of the painters met Monet over the course of the summer.

The accounts of Dawson-Watson and Breck conflict with those of Robinson and Metcalf, who claimed to have enjoyed Monet's hospitality in previous years. As art students in Paris, the younger painters certainly knew of Monet's reputation and, most likely, were aware that he resided in Giverny. Some of them had even attended the exhibition at the American Art Gallery in New York City in 1886 that featured Monet's *Meadow with Haystacks near Giverny*; if they missed the month-long exhibition, they could have seen it at the National Academy of Design, where it continued for another month to satisfy popular demand. Whether or not the "original Givernyites" were disingenuous in their recollection of the founding of their art colony, Monet rapidly became a factor in their work and their lives.

During that first summer, the little group of painters stayed at the Hôtel Baudy just up the road from Monet's house. Within a year, the colony expanded. Some of the original members rented houses for the summer, while others returned to the Hôtel Baudy. Many of the youthful painters were close in age to Monet's and Alice's children, and soon the Hoschedé and Monet sons – as well as the Hoschedé daughters – made the acquaintance of members of the growing art colony. When his children began to socialize with the young Americans, Monet, always a protective father, took an interest in the newest residents of Giverny.

JOHN LESLIE BRECK

Among the first of the Americans to experience the hospitality of the Monet-Hoschedé household was John Leslie Breck. Years after his return to the United States, he even boasted that Monet himself had urged him to come to Giverny. The elder painter's invitation was quoted in Breck's obituary, published in the *Boston Sunday Globe* on 17 March 1899: "Come down with me to Givetny [sic] and spend a few months, I wont' [sic] give you lessons, but we'll wander about the fields and paint together." Breck

Suzanne Reading and Blanche Painting by the Marsh at Giverny (detail), 1887, Los Angeles County Museum of Art. Monet's stepdaughters often accompanied him when he took his easel out to the countryside to paint. The bright and luminous palette of this dual portrait is representative of Monet's fresh approach to depicting figures in natural light, but his long-standing interest in figure painting faded within the next few years, and for the rest of his career he painted pure landscape.

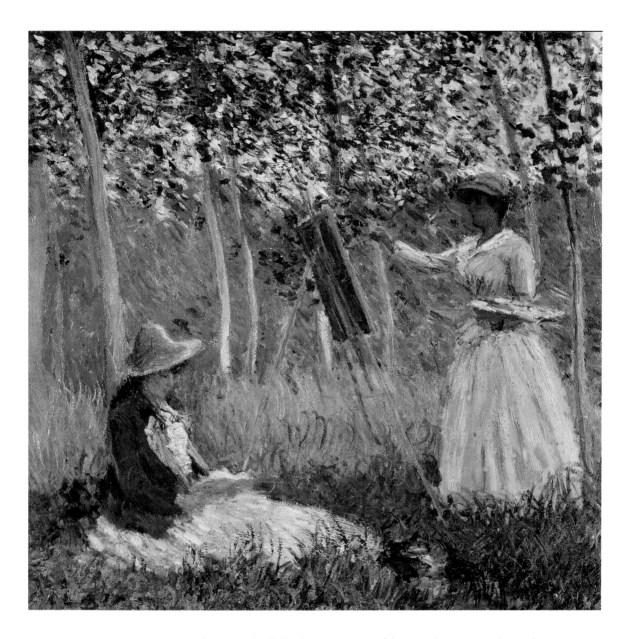

may have embellished – or even fabricated – Monet's uncharacteristic congeniality, but it is evident that as early as 1887 the young American artist had penetrated Monet's family circle and enjoyed the rare privilege of painting in his garden.

Born on a clipper ship in the South Pacific in 1860, Breck was raised in Boston. He began his formal art training in the United States, but in 1878, he enrolled in the Royal Academy in Munich. He returned home in 1883, settling in Massachusetts to paint landscapes, but three years later he left

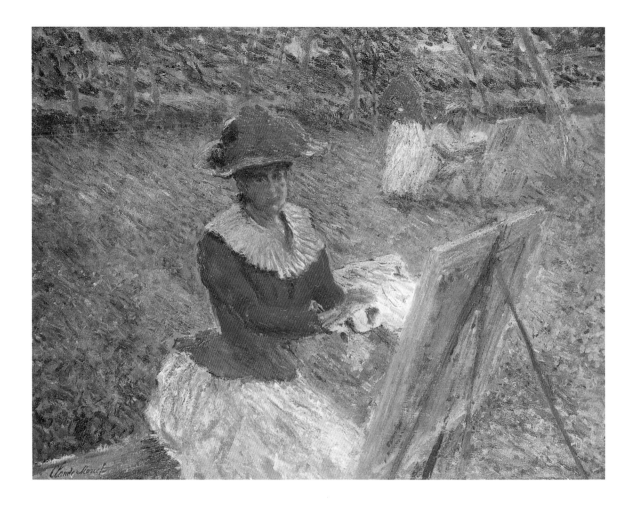

again, this time for Paris to study at the Académie Julien. Impressed by the naturalistic approach of the Barbizon School, Breck became a devoted *plein-air* painter. When he arrived in Giverny, he adopted a brighter, fresher palette and the rapid, broken brush strokes that betrayed a deliberate emulation of Monet's own *plein-air* technique. Breck also began to experiment with Monet's motifs. He painted the banks of the Epte, capturing reflections on the misty water, and, some time late in the summer of 1887, he painted Monet's flower garden. *Garden at Giverny (In Monet's Garden)* (see page 95) displayed Breck's new command of colour in the bright, full-blown roses rising above the densely planted foliage and the muted light dappling the garden path.

Breck continued to follow Monet's example. He painted a stand of yellow iris in 1888, and in 1891 produced a series of grain-stacks, observing the changing effects of autumn light during the course of the day. He

Blanche Hoschedé Painting, 1892, private collection. Blanche began to paint as an adolescent, and Monet took an active interest in his stepdaughter's work. Perhaps his greatest endorsement of Blanche's efforts can be seen in his portraits of her working at her easel in the open air. She is seen here, seated at her canvas in the dazzling sunlight, a closed parasol at her side. In the background, her sister Suzanne stands behind her fiancé, the American painter Theodore Butler.

had returned briefly to the United States in the summer of 1890, and in November of that year, six garden subjects were included in his first solo exhibition at the St. Botolph Club in Boston. The titles listed in the catalogue, such as *M. Monet's Garden* and *Chez M. Monet,* firmly linked his name with the Impressionist master for the American public. It is clear that Breck had established a close and comfortable relationship with Monet and his family. He sketched Suzanne in February 1888 and was photographed with Monet and Alice, as well as some of their children, in the garden in the following summer. But when Breck displayed his growing romantic interest in Blanche, Monet's attitude toward the young painter changed. Breck returned to Giverny in 1891, and, at that time, Monet made it clear to him that he had taken advantage of the family's hospitality. Before the year was over, Breck packed up and left Giverny for good.

In addition to his traditional fatherly concerns over his step-daughter's future, Monet also wanted to see Blanche fulfill her own artistic ambitions. At some time during her adolescence, Blanche began to paint in her stepfather's style, working in the garden and in the surrounding countryside. When Monet was away, he often asked Alice about Blanche's progress, wanting to make certain that she had enough canvas and paint to continue her work. Writing in November 1885, he told Alice to convey his encouragement, as well as some advice: "I'm glad to hear that Blanche has been painting, if she worked a little harder she would do quite well. Tell her that, and also tell her to draw – which she never does. Drawing will help her to get used to putting things in their places." Her light-struck canvases echo Monet's own spontaneous style, and Monet, perhaps with a bit of fatherly pride, painted her several times, working at her easel in the open air. Breck's departure did not impede Blanche's work, and, in 1897, when she married Jean Monet and moved to Rouen, she began to seek out her own motifs in the local countryside and exhibited her works, usually signing them with her birth name Hoschedé, at the Salon des Artistes Rouenais.

THEODORE BUTLER

Although he was not one of "the original Givernyites," Theodore Butler became more closely linked to Monet and his family than any of the founding set. Born in Columbus, Ohio, and schooled at the Art Students League in New York City, Butler came to Paris some time around 1886 to continue his education in the arts. He made the rounds of the popular academies, including the Académie Julien, Académie Colarossi, and the studio of Charles-Emile-Auguste Carolus-Duran. In the summer of 1888,

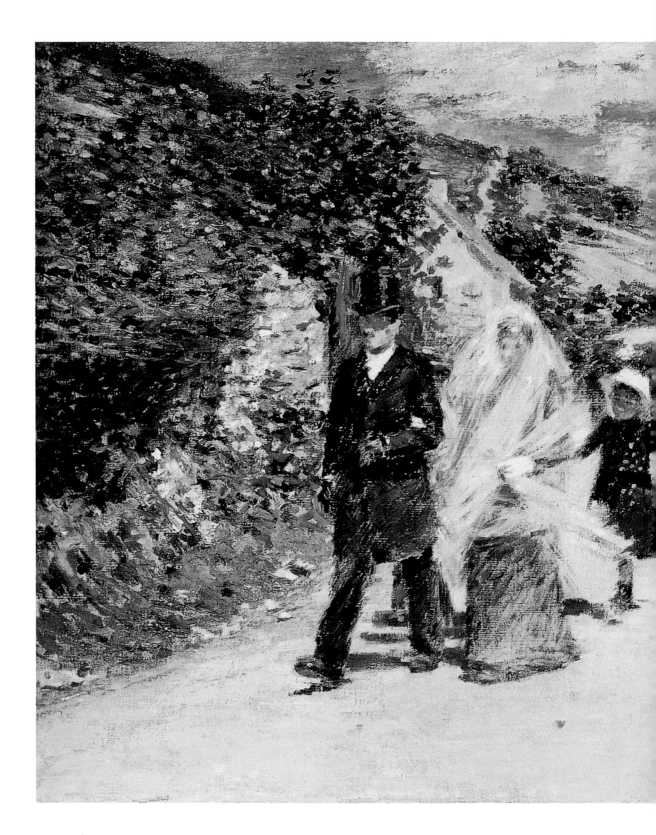

Theodore Wendell convinced Butler to join him in Giverny. Butler stayed at the Hôtel Baudy, and the camaraderie of the American colony, as well as the picturesque landscape, drew him back each summer in subsequent years.

Like the other artists in the colony, Butler enjoyed the easy companionship of Monet's and Alice's children. The older sons, Jean Monet and Jacques Hoschedé, shared a passion for hunting with some of the Americans. The Americans, in turn, organized picnics, parties, and theatrical productions that included the Hoschedé daughters as well. Over the course of his annual visits, Butler became enamoured of Suzanne, and in the spring of 1892, while Monet was in Rouen working on his Cathedral series, Butler summoned up his courage to ask Alice for her daughter's hand in marriage.

After Breck's experience, Butler had hoped to avoid a confrontation with Suzanne's intimidating stepfather, but on 10 March, when Monet received the news about the proposal from Alice, he wrote to her in fury, "If you only knew how your letter upset me! . . . I haven't been

Theodore Robinson, *The Wedding March*, 1892, Terra Museum of American Art, Chicago.
Robinson attended the July wedding of Suzanne Hoschedé to Theodore Butler, but he painted the event several weeks later in his studio. His warm palette and light, quick brush stroke captured the scene with genuine spontaneity. Monet and his stepdaughter lead the march, with the groom and Alice following. The civil ceremony at the *mairie*, or town hall, is over and the party is presented on their way to the church.

able to think of anything else this morning. And the more I think about it, the more disturbed and saddened I feel." He had long been suspicious of the intentions of those "transient Americans," and now, his own stepdaughter's lack of good judgement astonished him: "If this gentleman has dared to come and see you, it's surely because Suzanne encouraged his advances." Monet angrily concluded, "It is impossible for me to remain any longer at Giverny."

It took months to convince Monet to accept Butler as his son-in-law. Monet claimed that his opposition was based on his fear that as a painter Butler might "amount to nothing," and so, through Theodore Robinson, Alice made enquiries about Butler's family in Ohio. She discovered that they were respectable and affluent. The young couple then promised not to move away from Giverny. Finally, on 20 June, Suzanne had happy news for her fiancé: "Monsieur Monet plans to marry mother and so that things may be done properly, they both very much wish to do so before our wedding so that Monsieur Monet may be able to take my father's place and conduct me to the altar."

Suzanne married Butler on 20 July in a civil ceremony witnessed by Monet's brother Léon and Alice's brother-in-law Georges Pagny, both of whom had served as witnesses at the older couple's marriage four days earlier. The civil service was followed by a blessing at the church from the Abbé Anatole Toussaint, who was a close family friend. A breakfast in Monet's studio capped the festivities. Some of the American painters also attended, including Theodore Robinson, who described the happy event in his diary as "A great day."

Robinson also commemorated the event in his painting *The Wedding March* (see pages 100–101). Although Robinson did not begin work on the painting until several weeks after the wedding, his pale, sun-bleached palette and his feather-light brush stroke gives a sense of the immediacy of the moment. The two couples, Monet with his stepdaughter leading the way and Butler with his future mother-in-law behind, stride briskly from the *mairie,* or town hall, towards the church. Suzanne's swirling veil reveals that the religious ceremony has yet to take place. Robinson was more intent on preserving the high spirit of the day rather than accurate portraits; he even eliminated Monet's distinctive beard and joked that Butler's silk hat was his only model.

True to their promise, Butler and Suzanne stayed in Giverny. They lived at the Maison Baptiste, a cottage very close to Monet's own house, and Butler soon developed an interest in gardening. Two children were

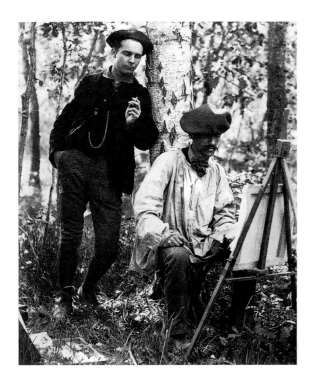

Theodore Robinson and Kenyon Cox, Terra Museum of American Art, Chicago.

Theodore Robinson was one of the first American artists to visit Givery. A bit older than the circle who regarded themselves as the "original Givernyites", Robinson struck up an enduring friendship with Monet, which they maintained even after the American painter left France in 1892 to pursue his career in New York. An avid photographer, Robinson used his camera as a studio aid. His photographs also document life in Giverny, including a portrait of Monet in his garden. Here, the American artist and writer Kenyon Cox leans against a tree watching Robinson paint *en plein air*.

born early in the marriage, James in 1893 and Alice, nicknamed Lili, in 1894. Butler continued to paint, shifting his focus from landscape to domestic scenes, particularly intimate interiors featuring his children and other subjects set in his garden. Although his concentration on his family life recalled the subjects Monet painted at Argenteuil during the first happy years of his marriage to Camille, Butler's artistic vision more closely resembled that of the Intimist painters, notably Pierre Bonnard and Édouard Vuillard. The Butlers' home also became the centre for a younger generation of artists who gathered in Giverny, but after Lili's birth, Suzanne's health degenerated. She suffered from a debilitating paralysis and eventually she became unable to care for her children. Her elder sister Marthe moved in to run the household, and Marthe cared for Suzanne until her death on 6 February 1899.

In the following year, Butler once again asked permission to marry one of Alice's daughters. His wedding to Marthe took place on 31 October, in spite of Monet's objections. But Butler remained a loyal son-in-law, and his assurance that he and his new wife would remain in Giverny placated Monet, who was devoted to his grandchildren.

THEODORE ROBINSON

In 1892, Theodore Robinson was the last of the original circle of painters to summer in Giverny. Born in Vermont, but raised in Wisconsin, Robinson sought his first art training at the Chicago Academy of Design. His studies were curtailed in 1870 by the onset of severe asthma; his health remained

fragile throughout his life. After four years of convalescence, he enrolled at the National Academy of Design in New York City, and, in 1875, he made his first journey to Paris. After three years, Robinson returned to the States, but went back to France in 1884. He made his first visit to Giverny in 1885, and after 1887, he divided his time between Paris and Giverny, with regular trips back to New York City to see exhibitions and visit dealers.

Robinson's maturity – he was nearly a decade older than the other "original Givernyites" – and his early introduction to Monet may have contributed to the strong bond of friendship the two men forged over the years. He was a welcome guest in Monet's home. But Robinson lacked the robustness needed to accompany the elder painter on his *plein-air* expeditions, and he turned his enthusiasm for photography into a studio aid, using the photographs he made out of doors to capture the moment when he could not spend the necessary hours in damp fields or under the burning sun. Robinson also photographed some of the residents of the village, members of the art colony, and even Monet himself, dressed in work clothes and wooden clogs (see page 43). Although Robinson had access to Monet's garden, he did not emulate Monet's garden motifs. Instead, Robinson used the garden as a setting for his genre scenes of village women engrossed in their mundane tasks or resting at their work.

Robinson spent his last summer in Giverny in 1892. He was working on a series of views across the Seine toward Vernon from a hilltop vantage point above the village. On 15 September, according to Robinson's diary, Monet paid him a studio visit to assess his current work. This was a rare act of friendship on the part of the elder painter, and after that December, when Robinson returned to New York City, the two men continued to correspond until Robinson's death in 1896.

LILLA CABOT PERRY

Boston-born Lilla Cabot Perry also enjoyed a lasting relationship with Monet and his family. The daughter of an affluent, cultured family, Lilla Cabot married Thomas Sargeant Perry, a scholar of English literature and the grandnephew of Commodore Matthew Calbraith Perry, in 1874. She began her art training later in her life, after starting her family. In Boston, Perry studied under Robert Vonnoh and Dennis Miller Bunker, both advocates of *plein-air* painting, and, in 1887, she and her family moved to Paris where she enrolled in the Académie Colarossi and the Académie Julien. In 1889, prompted by viewing Monet's paintings in the retrospective exhibition held in the Galerie Georges Petit that June, Perry

Blanche Hoschedé-Monet, *Bridge at the Giverny Gardens*, private collection.

To paint the water garden, Blanche selected a vantage point that recalls Monet's *Japanese Bridge* series of 1899–1900, but her style, with its characteristic calligraphic brush stroke, is more descriptive than that of her stepfather. Blanche rarely dated her paintings, but the lush growth of wisteria on the trellis and of the flowers at the water's edge capture the peak development of the water garden, during the years that Monet worked on the *Grandes Décorations*.

and her family travelled to Giverny. She was introduced to Monet through a mutual friend and, in the belief that "he was not appreciated then as he deserved to be," Perry enthusiastically promoted his works, seeking patrons for him among her friends when she returned to Boston that November.

The Perry family went back to France in 1891 and spent the summer in Giverny. Perry painted figure studies in interiors and in natural light, but she also worked *en plein air*. According to her husband, she even set

Frederick Carl Frieseke, *Lilies* (detail), Terra Museum of American Art, Chicago.

The American painter Frieseke and his wife Sadie lived in the house next door to Monet from 1906 to 1920. Frieseke claimed to know little about gardens, but Sadie enjoyed cultivating flowers. He used the beautiful garden she tended as a setting for his figure studies of fashionable women illuminated by the natural light (see detail on page 88).

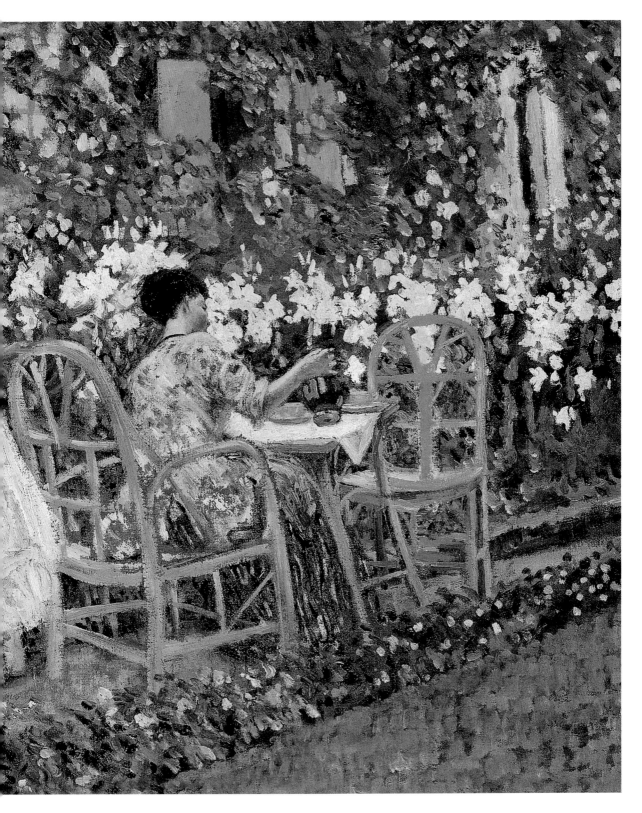

up her easel to paint the view out of his bedroom window, "a beautiful field which Monet often paints." Her friendship with Monet deepened in 1894, when she and her family rented Le Hameau, a house with a garden adjacent to Monet's own home. With much in common, the two families became good friends, and Monet felt fully at ease with his American neighbours. Perry recalled that he would "stroll in and smoke his after luncheon cigarette in our garden before beginning his afternoon work."

Perry also shared the advice which Monet gave her about her painting. In January 1894, she lectured at the Boston Art Students' Association. Although Monet refused to take on pupils, Perry told her audience that, "he would have made a most inspiring master if he had been willing to teach." He had urged her to look beyond the material objects that made up her composition and concentrate instead on the visual elements before her. She recalled his words: "When you go out to paint, try to forget what objects you have before you, a tree, a house, or whatever. Merely think, here is a little square of blue, here an oblong of pink, here a streak of yellow, and paint it just as it looks

Frederick Carl Frieseke, *Hollyhocks*, National Academy of Design, New York.
The luminous colour of Frieseke's *Hollyhocks* reveals how well the American painter assimilated the lessons of Impressionism. The slender woman in her robin's-egg blue gown echoes the tall flower stalks, laden with blooms. With a fresh approach to the image before him, Frieseke created an image of domestic pleasure.

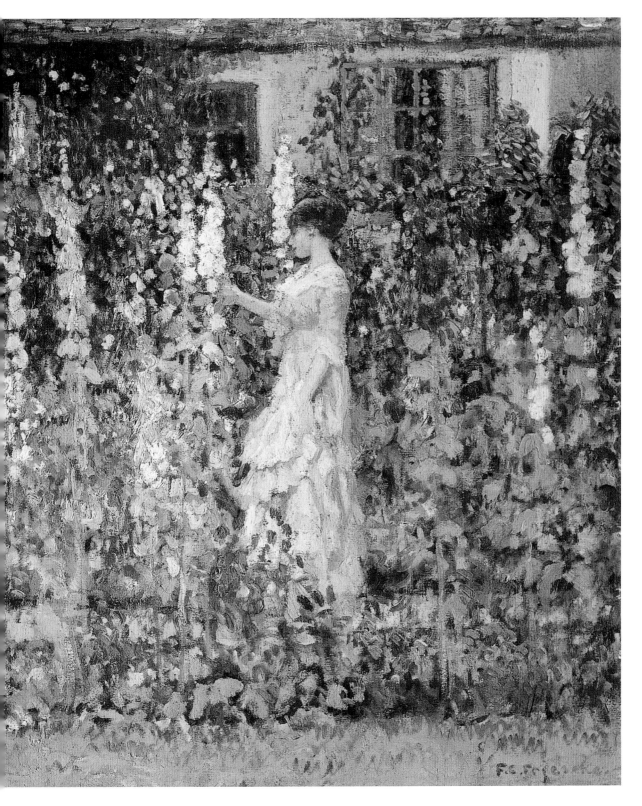

to you, the exact colour and shape until it gives your own naive impression of the scene before you." Perry's own *Autumn Afternoon, Giverny* reveals how well she absorbed Monet's directions. The high-keyed colour, dabbed on in sparkling, broken strokes, captures the ephemeral quality of light rather than the permanent elements of a view. Perry also gave her listeners a lucid explanation of Monet's artistic mission: "Monet's philosophy of painting was to paint what you really see, not what you ought to see."

Aside from Robinson and Perry, Monet tended to remain aloof from the growing population of American visitors that came each summer to Giverny. In 1897, he told an American reporter, "When I first came to Giverny I was quite alone, the little village was unspoiled. Now, so many artists, students flock here, I have often thought of moving away." Given his own deepening attachment to his water garden, Monet's thoughts of relocation were simply idle threats. But he became increasingly reluctant to open his door to curious admirers and, with the notable exception of the Perry family, had no interest in meeting his new neighbours.

The Michigan-born painter Frederick Frieseke first summered in Giverny in 1900, returning six years later with his new wife Sadie to rent the house next door to that of Monet. Sadie was an avid gardener, and Frieseke often painted in his garden, posing his wife and her friends in the sunlight in an echo of the intimate atmosphere of Monet's work in Argenteuil. But in the fourteen years that Frieseke lived in Giverny, he seemed to have had no contact with Monet. One of his friends, Karl Anderson, the brother of the writer Sherwood Anderson, tried to bridge the distance during a visit in 1909. Anderson and his wife were strolling through the village early on a Sunday morning. They paused in front of Monet's garden wall, and Anderson boosted his wife Helen up to have a peek over the wall into the garden. Helen was suddenly confronted with "the monumental figure of the long-bearded Monet," who looked back at her with a "somewhat condescending expression on his full red face." Anderson later discovered that, had they asked, Monet might have invited them for a tour of the garden. But they found their chance encounter far too disconcerting: "We hurried away like children stealing flowers."

Chapter 6
SANCTUARY OF FLOWERS

Irises (detail), 1914–1917, private collection. When the esteemed horticulturalist Georges Truffaut visited Monet in 1913, he was impressed with the varied types of irises that were cultivated on the banks of the pond. He admired the "oriental touch" achieved by the Japanese iris that bloomed late in the spring. Monet interpreted this Asian aesthetic through subtle suggestion in his painting. Long, light brush strokes and dabs of jewel-bright pigment convey the sensations of the flowers with an expressive force that transcends descriptive rendering.

Over the years, several visitors to Giverny made note of a curious souvenir that Monet displayed in his studio. In an article entitled "At Home with the Painter of Light," published in 1914 in the weekly *Je Sais Tout,* the journalist André Arnyvelde recalled being escorted into the master's studio, where he was allowed to view the paintings at his leisure. After a while, Monet directed Arnyvelde's attention to a yellowing envelope, displayed on a small easel in a glass-fronted cabinet. Instead of an address, the envelope was inscribed with a poem:

> *Monsieur Monet, que l'hiver ni*
> *L'étésa vision ne leure,*
> *Habite en peignant, Giverny,*
> *Sis auprès de Vernon, dans l'Eure.*

(Monsieur Monet, whom winter
nor Summer his vision can allure,
Lives, while painting in Giverny,
Close to Vernon, in l'Eure.)

With delight, Monet explained the letter came from his old friend, the poet Stéphane Mallarmé, who had died in 1898, and that it had arrived exactly as it had been addressed. Nearly two decades later, Monet still took pride in the meaning of the little keepsake: his art – and his artistic identity – was synonymous with Giverny.

Monet, no doubt, also enjoyed the legends that circulated about his garden. The American painter Philip Hale claimed that the gruff painter was *"passionné"* about his flowers and so tenderhearted that he could not bear to have anyone cut them. Journalist Arsène Alexandre expressed wonder that while horticultural exhibitions lasted less than a week, "there is no rest for the flowers of the garden at Giverny . . . Everything is designed in such a way that the celebration is everywhere renewed and ceaselessly replaced. If a certain flowerbed is stilled in a certain season, borders and hedges will suddenly light up." Even those who had not seen the garden could not resist describing it. In 1907, Marcel Proust shared with the readers of *Le Figaro* his desire to see Monet's garden, which he imagined as composed of artistic hues rather than of earthly blossoms. Proust disdained the notion that the great painter had created a flower garden; instead, he preferred to envision it as a "colour garden," "because it was planted so that only the flowers with matching colours will bloom at the same time, harmonize in an infinite stretch of blue or pink."

There is also little doubt that Monet took genuine delight in displaying his garden to his visitors and sharing its bounty with his friends. He urged guests to come at certain times of day and in certain seasons, so as not to miss the ephemeral effects. In an undated letter to his friend Caillebotte, Monet pressed him not to delay a planned engagement: "Be sure to come on Monday, as we agreed, for all my irises will be in flower; any later and some of them will be over." When visitors admired a particular flower, Monet often sent them a gift of bulbs or cuttings to add to their own gardens. Many of his friends shared his passion. In anticipation of a gathering that included Monet and Caillebotte, Mirbeau wrote to Monet, "We'll talk gardening, as you say, because as for art and literature, it's all humbug."

Monet may have preferred to talk about flowers over art, but he acknowledged that for him, the two were inextricably linked. In a conversation with the critic François Thiebault-Sisson, Monet once reflected, "I perhaps owe it to flowers for having become a painter." Although his painting testified to his deep love for every aspect of nature – light, diurnal and seasonal change, water, and the varied terrain of his native Normandy – observing the annual decline and renewal of his garden had taught Monet to trust the cycle of nature. With their natural beauty, flowers may have guided his early experiments in colour and light, but by tending his garden through the years in Giverny, Monet revitalized the creative force of his art, even when he felt that his own life force was beginning to wane.

Katsushika Hokusai, *Chrysanthemum and Bee*, c. 1832, Victoria and Albert Museum, London. Monet was especially intrigued by the subtle economy of means of the Japanese aesthetic that he defined as the power to suggest the whole of an image through the depiction of only a fragment. The *ukiyo-e* master's subtle rendering of the spiky blossoms may have influenced Monet's own painting of chrysanthemums begun later that year.

FLORAL SUBJECTS

Flowers and gardens had always comprised a significant portion of Monet's motifs in art. Of the more than eight hundred works attributed to the first twenty-five years of Monet's career, at least one hundred featured flowers and gardens. In 1883, after his move to Giverny, the number steadily increased, and during the last twenty-five years of his career, floral subjects outnumbered all others and eventually became his exclusive mode of expression. The move to Giverny also marked a transformation in the way Monet looked at his floral subjects and translated his observations onto canvas. In earlier compositions, Monet had portrayed flowers as part of a larger ensemble, as seen in the public gardens he painted during his years in Paris or in his gardens in Argenteuil and in Vétheuil. On rare occasions, he painted traditional floral still life, such as the bouquet of chrysanthemums he painted in 1878 and vases filled with dahlias, mallows, and sunflowers painted in 1881. Six years later, when Monet painted the peonies growing in his flower garden, he abandoned all convention (see page 46). He allowed the heavy flowers, blooming on crowded bushes, nearly to fill the picture frame. The peonies marked the first stage in Monet's elimination of all conventional references to setting beyond the floral motif. Rather than constructing a perspectival composition, with recessional space and a discernible horizon, Monet riveted his gaze on the flowers, expressing his close observations in a pure, painterly language of colour and textural brush strokes.

Bed of Chrysanthemums (detail), 1897, Kunstmuseum, Basle. These chrysanthemums represent a visual breakthrough in Monet's approach to floral imagery. Nothing intrudes on the spectacle of the bright blooms, crowding the canvas from edge to edge. By releasing the forms of the flowers from their setting – either in the context of the garden or as cut blooms in a vase – Monet defied the conventions of floral painting and pioneered a new vision that culminated in his *Nymphéas* series in the next decade.

THE CHRYSANTHEMUMS

In June 1898, Monet exhibited four chrysanthemum paintings at the Galerie Georges Petit in Paris. Although they were dated 1897, it is likely that he began work on them as early as the previous November, when he mentioned in a letter that he was busy painting flowers. In each work, the spiky blooms crowd the canvas from edge to edge. There is no hint of setting, no contour of the bushy plants, no sense of receding space, and no indication of the surrounding garden. Monet painted only the flowers, the bright hues of their petals described in pure pigment and a feathery brush stroke. By limiting his gaze to his motif at the exclusion of its context, Monet saw the chrysanthemums as a colour field; the vivid petals became lithe and vital slashes of pink, yellow, orange, and crimson, packed into dense balls and suspended upon a bed of blue-green leaves. Monet's approach to these chrysanthemums forecast his vision of his water lilies, both his first tentative experiments of 1897 (see page 57) and his masterful *Nymphéas* series of 1904–1908.

More than a decade before he painted his chrysanthemums, Monet had undertaken a suite of panels featuring fruit and floral imagery for the doors of the dining room in Paul Durand-Ruel's apartment in Paris. Several of the smaller panels feature flowers in isolation – peonies, poppies, and chrysanthemums – while the larger panels depict flowers in vases. The *Chrysanthemums* of 1896–1897 may represent the natural expansion of his concept for the smaller panels, but just prior to painting the later works, Monet's attention was drawn to another influence. In February 1896, he was in correspondence with the print dealer Maurice Joyant. Monet was seeking to complete his series of flower prints by *ukiyo-e* master Hokusai, and he inquired about the subjects that Joyant had in stock: "You don't mention poppies and that's important because I already have iris, chrysanthemum, peonies, and volubilis." More than simply indicating the desires of an avid collector, this letter reveals that Monet owned Hokusai's *Chrysanthemum* (see page 115), which features elements that may have inspired Monet's approach to his own *Chrysanthemums* later that year. Hokusai's flowers are similarly crowded together, with the spiky petals of the dense blossoms floating on their dark green leaves in empty space.

Whether Monet made a deliberate attempt to translate what he saw in the work of the *ukiyo-e* master into his own vernacular or whether he had already assimilated the idea into his mature flower imagery, his painting reflects his admiration for the Japanese aesthetic. Years later, in a conversation with critic Roger Marx, Monet proclaimed his deep

Irises (detail) *c.* 1914–1917, National Gallery, London. The iris was always one of Monet's favourite flowers. He painted fields of wild iris during his first years at Giverny, and he had them planted in densely massed beds along straight paths in his flower garden. Several varieties of iris flourished on the banks of his pond. The serpentine line of the path in this painting reveals that the location was the water garden. Monet echoed this rhythm with a sinuous stroke, suggesting the rustle of the wind beneath the leaves.

sympathy with the exquisite taste of the artists of Japan, who had the rare power to "evoke a presence by means of a shadow and the whole by the means of a fragment." When Marx pressed Monet to cite his influences, the painter responded: "If you absolutely must find an affiliation for me, select the Japanese of olden times."

NEW DEPARTURES

After painting the closely focused *Chrysanthemums,* Monet turned his attention to his water garden, but during the first three years of the twentieth century, he also studied his flower garden from a broad vantage point. Between 1900 and 1902, he produced eight canvases from different points of view on the Grande Allée, looking toward the house or across

the beds of flowers (see pages 47 and 48–49). Although not conceived as a series – nor did it seem that he painted them for exhibition – this small group of paintings record the visual spectacle as the flower garden came into its maturity. Vital and exuberant, the paintings marked a departure in the direction of Monet's work in the twentieth century. For the next decade, the water garden would command his sole attention as a floral motif, and in later years, when he painted the flower garden again, he would work more from his memory than from his perceptions.

Although Monet's passion to paint his water lilies drew his attention away from his more traditional flowers, the flower garden continued to be a source of pride and pleasure for the painter. It also inspired other residents of Giverny to cultivate their own gardens. When Monet moved to the village in 1883, the gardens tended by the residents were exclusively practical: kitchen plots for vegetables and orchards for fruits. Few of the townspeople shared Monet's interest in flowers – the local priest, Abbé Toussaint marked an exception – and Monet's clear preference for decorative flowers over productive vegetables and fruit trees was seen as the extravagant indulgence of an urban outsider. But, with the growth of the art colony, Giverny slowly but steadily became a village of residential gardeners. Floral painter Mariquita Gill first arrived in Giverny in 1889. From 1892 to 1897, she and her mother rented a house in Giverny, where she cultivated a flower garden to provide the motifs for her work. Her little garden became an afternoon retreat for the younger American painters, who often gathered there for tea. Monet's son-in-law, Theodore Butler, also enjoyed gardening and learned from his father-in-law's example.

Lilla Perry and her family kept a decorative garden, but the only garden in the village that was seen to rival Monet's was tended by Frederick and Mary Fairchild MacMonnies. The couple, both painters, moved to Giverny in 1897 and rented Le Prieuré, a three-acre estate originally built as a monastery. They made their home a showplace, to serve as the salon of the American artistic community. They also transformed their garden, following the formal tradition, with geometric beds, bordered gravel paths, and a terrace embellished with copies of antique sculpture. Another American painter, Mildred Giddings Burrage, preferred the MacMonnies's garden to Monet's for while the latter impressed with its "tumult of colour," the former provided genuine "rest and repose."

Entry into Monet's flower garden remained the most desired invitation in Giverny. As an advocate of Impressionism, the young British painter Gerald Kelly longed to meet Monet and view his works in his studio.

Irises by the Pond, 1914–1917, Virginia Museum of Fine Arts, Richmond. The irises in the flower garden were planted in beds to create a floating haze of colour, but those around the pond grew in freer, more accidental clusters. Here, Monet indicated the winding path with a dabbled patch of burnished ochre in the upper centre of the composition, just below a glimpse of the cool blue of the pond. Using a more exuberant stroke, he painted the whiplash foliage and resplendent violet and pink blooms as streaks of glowing colour.

Durand-Ruel generously offered to introduce him to the old French master, but only under one condition: that Kelly be ready to speak at length with Monet about gardening. To prepare for the intimidating encounter, Kelly returned to England, to brush up on his knowledge of horticulture, but, when he finally made the anticipated pilgrimage, he found that Monet was not interested in conversation. He only wanted to tour Kelly around his garden. The day was overcast, and when Kelly suggested that their time would be better spent in the studio, Monet protested: "No, no, come out into the garden. You must see my flowers, they are lovely." The old painter declared the day perfect for looking at flowers, claiming that too much sun was the "ruination of flowers, they look so bright you can't see them." But after a while, the sun burst through the clouds, and to Kelly's relief Monet sighed in exasperation, "Here's the sun, let's go back to the studio."

SHATTERED SERENITY

Early in 1910, Monet faced the first crisis in a traumatic turn of events that shattered the serenity of his life at Giverny. Unusually heavy rains had soaked the region of the Seine valley throughout the previous year, and in January 1910, the river broke through its banks and flooded the low lying land around it. Located along the rise of a hill, Giverny was, for the most part, spared, but the waters submerged the main roads, as well as the homes and farms on the outskirts of the village situated on the lower slope leading down to the Epte. Monet's house lay in the path of the flood. The water garden was completely submerged; only the drum bridge rose above the

Water Lilies and Agapanthus (detail), 1914–1917, Musée Marmottan-Monet, Paris. In 1952 Monet was diagnosed with double cataracts. He refused the prescribed operation, despite his physician's promise of good results, fearing that his vision would be irreparably changed. To accommodate his dimming sight he avoided working in the brilliant morning light, finding that he was able to observe his subject with greater precision in more subtle illumination. The muted tones he used to depict the water lilies and agapanthus evoke the low light just before dusk, but the delicacy of the rendering reveals that his acuity of observation was undiminished.

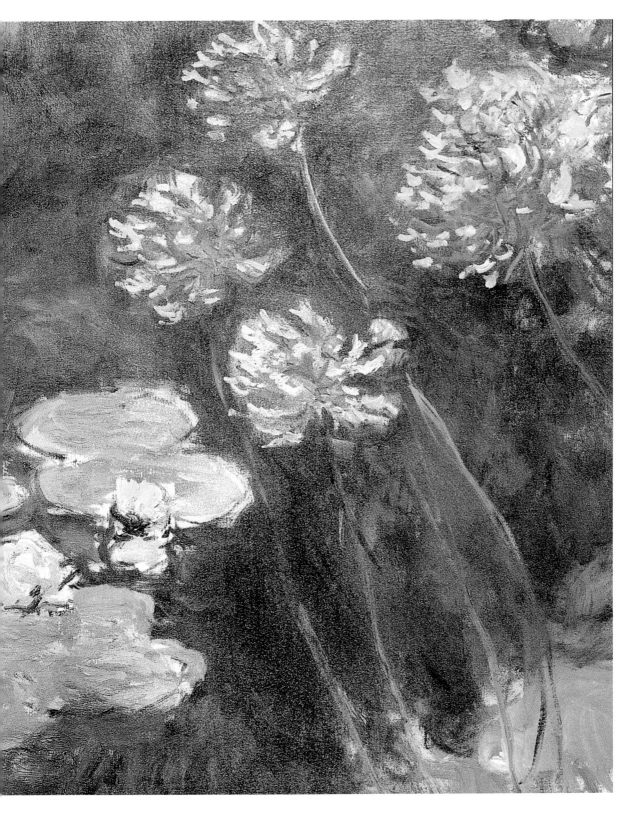

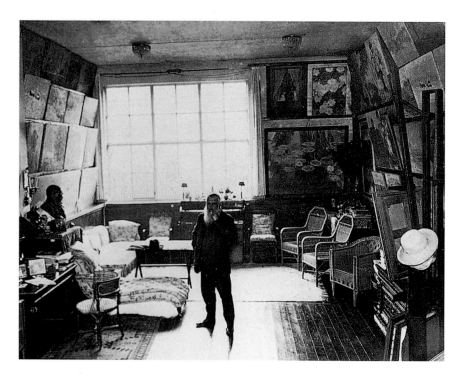

flood waters that flowed across the road bordering his property and into the flower garden, ebbing halfway up the Grande Allée.

Mirbeau wrote to Monet, to urge him not to lose hope: "Do remember, my dear friend, that you are one of those who has lost least, and that your beautiful garden, which was the great joy of your life, has certainly not suffered so very much. You will see it emerge from the water... Come now, my dear old Monet, be brave." Mirbeau was right. By the first week of February the flood waters began to retreat, but Monet's despair was slower to abate. Although many of the plants perished, the garden survived, and in the process of repairing the water garden, Monet had it enlarged one last time, making certain to have the workmen reinforce the banks.

Monet took little pleasure in restoring his garden after the flood, for in March 1910 Alice was diagnosed with myelogenus leukemia. Since the death of her daughter Suzanne, Alice had been in a fragile state, prone to bouts of depression and physical exhaustion. Early in March, she became too weak to leave her bed, and by mid-April, her physician warned that there was little hope for recovery. Alice experienced a remission that summer, gaining enough strength to leave her bedroom and join the family for lunch in the garden, but for the rest of the year her health remained precarious. In the spring of 1911, Alice suffered a relapse and she died on 19 May.

At the funeral three days later Monet appeared devastated. Without his life's companion he was lost. His friends Geoffroy and Clemenceau urged him to find solace in work, and by October, Monet informed Durand-Ruel that he planned to touch up some of the paintings from his stay in Venice with Alice. But he gave up in despair, writing "I am completely fed up with painting and I am going to pack up my brushes and my colours for good."

Monet's grief was compounded with worry about his eldest son. For several years, Jean had been plagued by an ongoing neurasthenia. His doctors were unable to diagnose or treat his increasing enervation, and by 1910, he had lost his job as a chemist in Rouen. Monet encouraged Jean and Blanche to come back to Giverny, and at first, Jean felt energized and optimistic, running a trout farm in nearby Beaumont-le-Roger. But in 1912, his health failed again, this time manifesting in a mental breakdown that his physicians attributed to a cerebral congestion. Jean's decline was steady and debilitating. That summer, he suffered a stroke and never fully recovered his mobility or his reason. In 1914, while visiting his father in his studio, Jean collapsed and died shortly after on 9 February.

Blanche Hoschedé

LEFT Blanche Hoschedé-Monet, *The Rose Arbour at Giverny*, private collection. The abundance of blooms on the rose arches in this fresh and shimmering composition suggests that Blanche painted the roses at their height of beauty, which usually occurred in June. Georges Truffaut took note of Monet's rich and varied use of roses when he visited his gardens in 1913. He compared the effect of the gardens in full flower to a fireworks display, and he remarked that passersby "must yearn to visit this fairyland," when they caught a glimpse of colour through the gate as they walked along the *chemin du Roi* bordering Monet's property.

TOP RIGHT Nickolas Muray, *Monet under the Rose-Covered Gate*, 1926, George Eastman House, Rochester, New York. Monet's grief at the loss of his wife Alice was compounded by the devastating news of his son's failing health and his own diagnosis of cataracts. Although his friends urged him to find consolation in his work, Monet had little heart for painting during those troubled years. But he spent hours in his garden, observing the natural cycle of decline and rebirth. When he picked up his palette again, he painted his flower garden and the rose trellises that led to his pond, finding that his favourite motifs renewed his sense of purpose and his desire to paint.

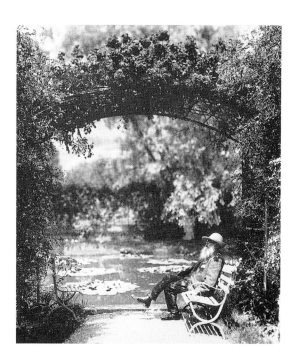

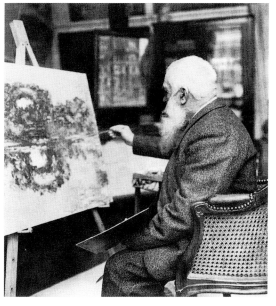

ABOVE RIGHT André Arnyvelde, *Claude Monet Painting*, 1913, The Louvre, Paris.
In November 1913, when journalist André Arnyvelde came to Giverny to interview Monet for the popular weekly *Je Sais Tout,* the painter confessed, "I don't work much anymore . . . For three years of horribly cruel mourning I didn't work at all." Monet explained that just a few months prior to Arnyvelde's visit he had, in fact, begun to work again. To illustrate his article, Arnyvelde photographed Monet in his studio retouching this recent work, a view of the rose arches painted in their summer resplendence (see page 128).

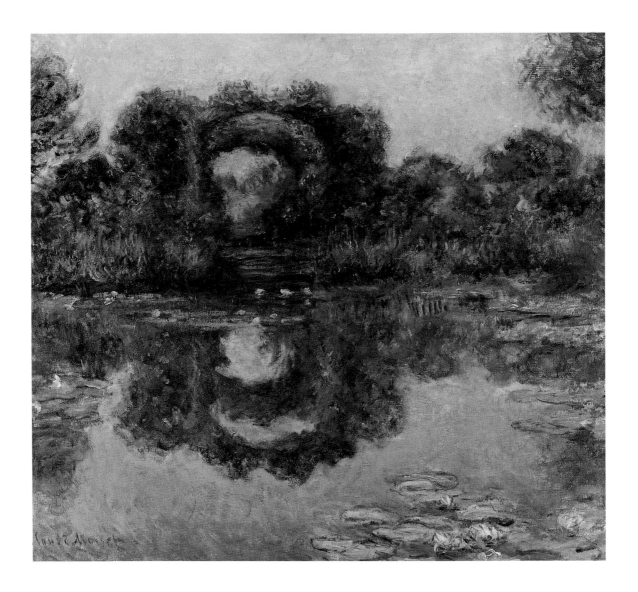

As his son's health was failing, Monet was forced to confront other devastating news. After years of headaches and occasional bouts of eye strain, Monet finally consulted a doctor about his clouded vision, and on 26 July 1912, Monet was diagnosed with double cataracts. His physician recommended an operation, strong in the conviction that Monet was an excellent candidate for recovery. But Monet refused, explaining that: "The operation is nothing, but afterwards my sight will be totally changed." Unwilling to risk the unpredictable results, Monet resigned himself to a future in which his sensory memory would illuminate his darkening world.

Flowering Arches, Giverny,
1913, Phoenix Art
Museum.
Three paintings of the
rose-covered pergolas
in the water garden,
undertaken after three
years of virtual inactivity,
initiated the last – and
one of the most intensely
focused – phases of
Monet's career. His
vantage point on the east
bank presented a wide
panorama of the newly
restored water garden, but
it also reacquainted the
painter with his favourite
motifs: his lilies and the
reflections glimmering on
the surface of the water.
The vaporous atmosphere
and the volatile sky show
Monet's expressive powers
had not diminished,
despite his wavering and
waning sight.

As Monet had discovered during the months of grief that followed the deaths of Camille and Suzanne, painting brought him little consolation when he lost Alice. He made an attempt to paint in the summer of 1912, after his cataracts were diagnosed. He set up his easel in the flower garden for two views of his house, but his disconsolate mood and the prospect of losing his sight undermined his confidence, and he felt as if he were "a beginner with everything to learn." But in the new year, Monet travelled to St. Moritz with his younger son Michel and his grandchildren Jimmy and Lili. He returned in better spirits, writing to Durand-Ruel that he planned to return to Switzerland to paint.

In July 1913, Georges Truffaut, a noted botanist and author of several popular books on gardening, paid Monet a visit. Monet proudly escorted him through both his gardens, now restored to their original splendour. Truffaut was so impressed with Monet's irises he encouraged Félix Breuil, the head gardener, to write an article on the varieties that he cultivated in both the flower and the water gardens. When Breuil completed his study, Truffaut had it published in the gardening journal *Jardinage.* Much later, in 1924, Truffaut wrote a description of Monet's gardens for the same review. After a meticulous inventory of the two gardens, Truffaut praised Monet as "the greatest of all floral decorators." While he acknowledged that Monet was a superb painter, he also concluded that "Claude Monet's most beautiful work, in my opinion, is his garden."

Later that summer, Monet painted the rose-covered trellises that disguised the view of the railroad tracks from the water garden. He positioned his easel on the east bank of the pond, giving him a broad view across the water that took in the glimmering reflections on the surface as well as the voluptuous forms of the flowered arches against the sky. He painted three canvases as a short series, maintaining the same vantage point, but observing the volatility of light. One of the paintings evokes the sensation of mist rising over the glistening water, where pale lilies float over the muted reflections of the roses. The beautifully composed canvas, with its subtle palette and palpable atmosphere, betrays no evidence of depressed spirit, diminished power, or impaired vision. By returning to his garden, Monet regained his sense of purpose. Once again, he embraced his work, expressing his wonder at the spectacle of nature and finding contentment as he worked among his flowers.

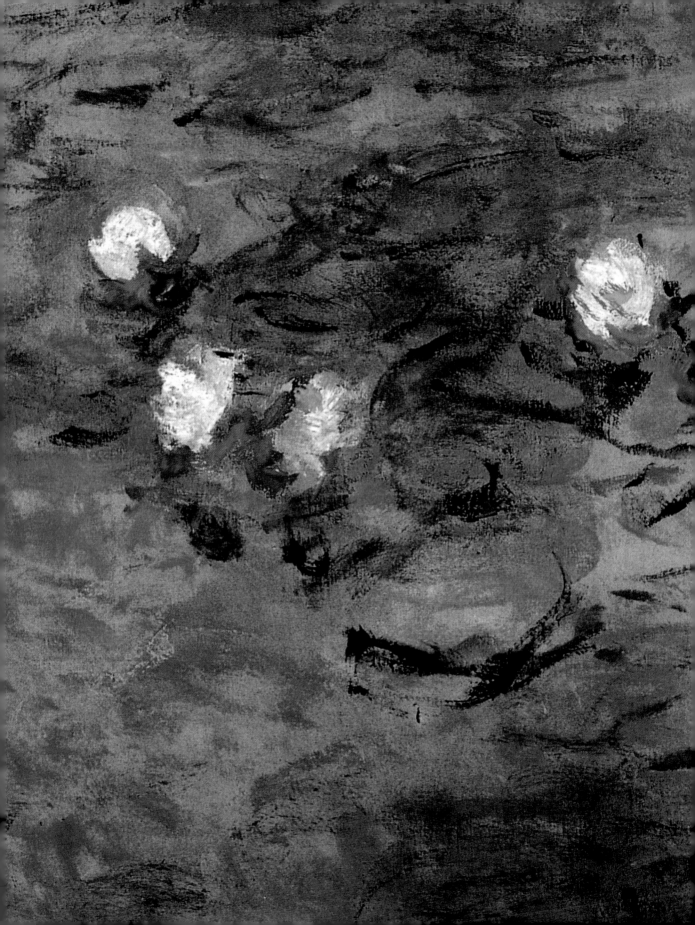

Chapter 7
RESTFUL WATERS

Morning, Grandes Décorations (detail), 1920–1926

On 30 April 1914, Monet shared some heartening news with his old friend Geoffroy: "I'm in fine fettle and fired with a desire to paint." The recent spate of tragedies in Monet's life – the loss of his wife and son – had depressed his desire to work, and his friends believed that his repeated threats to retire from painting were genuine. In his letters, Monet had lamented that despair had dulled his senses, making him unable to take an interest in the world around him. Even worse, Monet's confidence seemed shattered. When Durand-Ruel tried to convince him that his work was valued, he countered, "I realize just now how illusory my undeserved success has been." Even his persistent drive for perfection failed him, for now, he confessed, "age and unhappiness have sapped my strength." Early in 1913, he agreed to his dealer's request to touch up a few canvases, but he cautioned him, "after that I really have finished."

Now, a few months after his son's death, Monet not only allayed his friends' fears, but also assured Geoffroy that he was ready to embrace a new challenge: "I am even planning to embark on some big paintings, for which I found some old attempts in the basement." He was referring to the preliminary studies of water lilies made in 1897 (see page 57), which he had shown to the journalist Maurice Guillemot in the course of an interview. Guillemot found them "dreamlike" in their delicacy, but even more intriguing was the artist's plan to explore their decorative potential for a circular room, where the image of still water and floating lilies would delight the eye and soothe the senses. In the years following his work on

these studies, distress at the death of his stepdaughter Suzanne and other worries had drained his emotional energy, forcing him to take a break from painting. When Monet returned to work in the summer of 1899, he focused his attention on the *Japanese Bridge* series, and the water lily studies were neglected.

But he had never forgotten his idea for an ensemble that would immerse a viewer in the sensations of his pond. In a conversation with the critic Roger Marx some time before the exhibition of the *Nymphéas* series, Monet mentioned the scheme. "I was once briefly tempted to use the water lilies as a sole decorative theme in a room. Along the walls, enveloping them in the singleness of its motif, this theme was to have created the illusion of an endless whole, of water without horizon or shore." Monet saw the room as a refuge, where the cares of daily life would ebb away. "Here," he explained, "nerves taut from overwork could have relaxed, lulled by the restful sight of those still waters."

Monet's desire to explore his artistic themes in an interior design may have been prompted by his friend Caillebotte's decorations for his own dining room at Petit-Gennevilliers in 1894. He may also have drawn inspiration from Japanese screens, which could be positioned to surround a viewer with a field of exquisite imagery. He had evidently spoken to others about his idea. In his review of the *Nymphéas* series in the journal *Comœdia,* Arsène Alexandre lamented that the paintings would soon be dispersed, making Monet's dream of an extended painting of his water garden, encircling a room with "mysteriously seductive reflections," all the more elusive.

Monet's friends also held out the hope that he could make his decorative dream a reality. In 1908, Geoffroy became the Director of the Manufacture Nationale des Gobelins. He had been appointed by Clemenceau, who had become the Premier of France in 1906. Geoffroy awarded his first commission to Monet, asking him to transpose one of the early *Nymphéas* paintings into a design for tapestry. Work did not begin on the design until 1910, and the commission, expanded to three tapestries, was completed in 1913. Despite the emotional strain of his personal circumstances, Monet found each step of the project intriguing. But he retained a grander vision for a room which would enfold the viewer in the mystery and the beauty of his pond.

Monet's decision to revive his plan for a decorative ensemble of water lilies was hardly as sudden as he suggested in his letter to Geoffroy. The years of concentrated work on the *Nymphéas* series had convinced him of

The Water Lily Pond at Giverny, 1918–1919, Musée de Grenoble. In the months that followed Monet's promise of the *Grandes Décorations* to France, he shifted his attention from his work in progress to an intimate corner of his pond. He painted several smaller-scale canvases from the same vantage point, looking at the curving bank opposite the Japanese bridge. There is a sense of intimate enclosure in this corner of the pond; the trees in the background define the bower-like space, lush with climbing roses rising above the grassy banks.

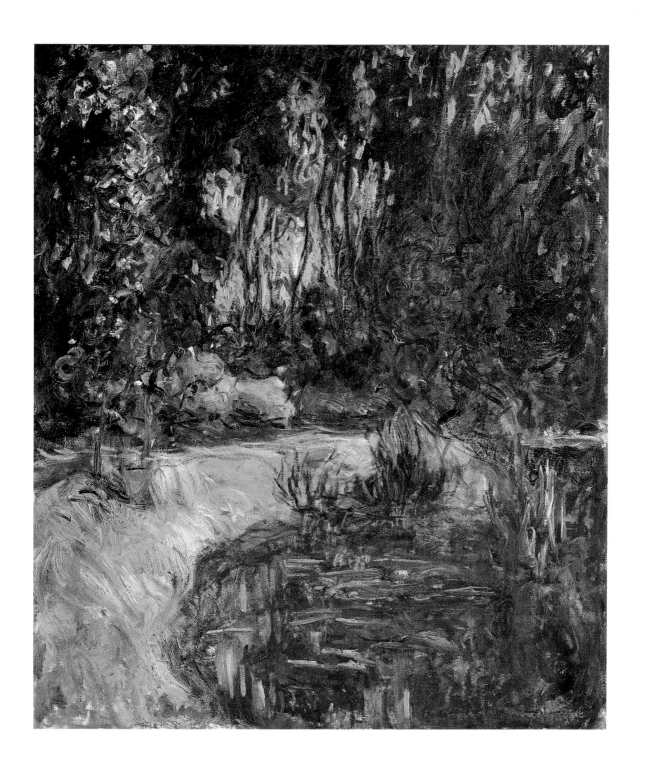

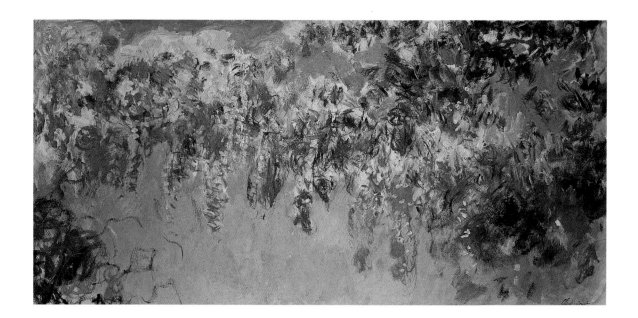

the infinite possibilities of the motif, and his demand that Durand-Ruel install the works as a visual suite, without verbal explanation, confirmed his belief in their decorative potential. Around the time of the exhibition, he mentioned the plan to both Marx and Alexandre, and he did not dissuade them from sharing it with their readers. And there is evidence that he had rediscovered the old studies well before he described them to Geoffroy; one of them appears framed and hung on the wall in the studio drawing room in a photograph taken by André Arnyvelde when he came to Giverny to interview Monet in November 1913 (see page 124).

Monet broke his long spell of inactivity in the summer of 1913 by painting the rose-covered arches (see page 128). But the short series may also be regarded as a prelude to his new challenge. In the course of working on the *Nymphéas* series, he had pulled back from his tight focus on the water's surface in 1905 to paint several views of the Japanese bridge, as if to reorient his vision. He had followed this departure with a more daring presentation of the water's surface, eliminating all reference to the surrounding terrain. The panoramic views of the rose-covered arches may have served the same purpose, grounding his view in the water garden's totality as a context within which he could observe its most subtle nuances and infinite details.

In the summer of 1914, when Monet began to paint again, he worked with speed and confidence, capturing the most fugitive effects of light and motion with a freedom of stroke and colour unparalleled in the earlier

ABOVE *Wisteria*, 1917–1920, Musée d'Art et d'Histoire-Marcel-Dessai, Dreux. Monet envisioned the *Grandes Décorations* as an unbroken panorama of "water lilies . . . spread over a huge surface." But the presence of doors into the room posed a practical problem. Clemenceau joked that a visitor needed to be dropped into the space from the ceiling to avoid interrupting the effect. In response, Monet painted wisteria branches, seen against the backdrop of the sky, that could bridge the panels as a frieze above the intervening doors.

series. He also worked on an unprecedented scale, covering canvases nearly double the size of those used for the *Nymphéas* series. To reach them, Monet perched atop a tall stool, under the shade of an enormous parasol. He also learned to accommodate the limitations of his eyesight, avoiding the brilliant sunlight by working early in the morning and late in the day. Immersed in his work, Monet felt reinvigorated and wrote to Durand-Ruel that his day began at four in the morning and ended only in the evening when exhaustion depleted him. He jokingly admitted, "you know I don't do things by half" and assured his dealer that he was in good health; even his vision was stable.

PEACE DISRUPTED

But before the summer's end, Monet's peaceful refuge was disrupted. The conflicts over the Austro-Hungarian succession that had erupted after the assassination of Archduke Ferdinand on 28 June had led to war in eastern Europe. Early in August of 1914, German forces marched on the western front, invading Luxembourg and Belgium. France was pressed into war, and the northern regions of the nation were endangered.

Within days of the official declaration, Jean-Pierre Hoschedé was mobilized and, much to his stepfather's grief, sent to the front. Monet's youngest stepdaughter Germaine, now married, moved with her family

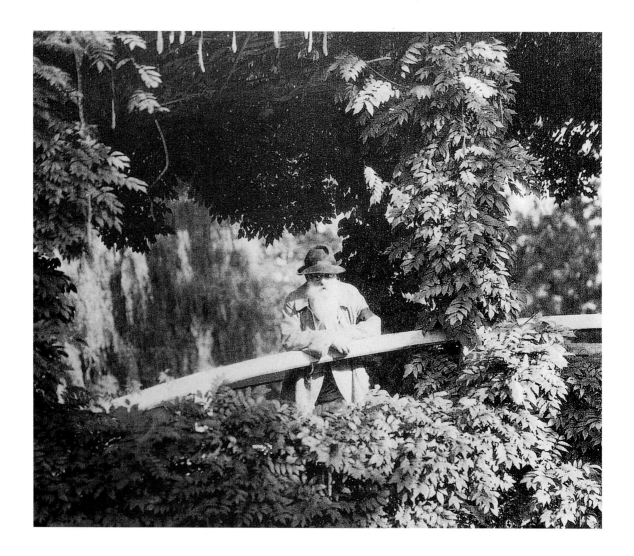

to the comparative safety of Blois in central France. Monet feared that his youngest son Michel would soon be conscripted, but for the time being, Michel remained at home with his father and Blanche, who had moved back into the family home after the death of her husband. On 1 September, Monet related this news to Geoffroy, as well as his conviction to stay in Giverny: "As for myself, I'm staying here regardless and if those savages insist on killing me, they'll have to do it in the midst of my paintings, before my life's work."

During the early days of the war, Monet was too distressed to paint. The season for the lilies passed, and it was not until late in November that he felt able to resume his work. He painted in the studio, drawing upon his memory to adjust the colour effects of his large studies. Once

again, he turned his full attention to his work, motivated by his desire "to avoid thinking of troubled times." But the horrors of the ongoing conflict encroached upon his isolated life in Giverny. He worried about his stepson's fate; the sons of both Clemenceau and Renoir had been wounded. His own surviving son Michel was able to avoid conscription until November of 1915, but when he was shipped out, he was sent to the front. Monet persisted in his work, but confessed to Geoffroy that he felt guilty and self-indulgent: "I should be a bit ashamed to think about little investigations into forms and colours while so many people suffer and die for us."

But Monet made his own contributions to the war effort. When a hospital for wounded soldiers was set up in Le Prieuré, the house formerly occupied by the MacMonnies family, Monet supplied all the vegetables needed for provisions. He also allowed his friend, the actor, playwright and film director Sasha Guitry, to film him at work on his studies in 1915 for a patriotic documentary on French cultural heritage.

Monet first referred to his work in progress as the *Grande Décorations* in a letter to Raymond Koechlin, the former president of the Société des Amis du Louvre, dated 15 January 1915. He summed up the plan rather simply to Koechlin – "water, water lilies, plants, spread over a huge surface" – but he emphasized the scale of the undertaking, especially in view of his advanced age. In June, Monet hosted a meeting of the members of the literary society Académie Goncourt, including his friend Mirbeau and Lucien Déscaves, who wrote an account of the visit for *Paris-Magazine*. Déscaves expressed astonishment at the scale of the new water lily paintings and he noted that, in the presence of these works, his articulate colleagues stood in silence, with nothing more to say than "It's beautiful!" He also remarked that the studio was inadequate to house the vast paintings, but now Monet planned to build a new studio large enough for his work. Construction began in August and was completed late in October. Monet regretted the great expense – nearly twice the price he had paid for his house and grounds twenty-five years earlier – as well as the plain exterior design that detracted from the beauty of the building's surroundings. But the new studio, with its vast space and northern light streaming through the glass ceiling and controlled by blinds, provided Monet with an ideal working environment.

Throughout the first months of 1916, Monet worked ceaselessly. He wrote to his stepson Jean-Pierre in February that, "I am so taken with this confounded work of mine that as soon as I am up, I run to

my big studio." In May, he informed Koechlin that his sight was "good enough to enable me to work hard... on these blessed *Décorations* which obsess me." A group of photographs taken at this time documents his progress. Over the year Monet had been transferring the fleeting effects he captured on site at the water garden onto grand scale canvases he called *panneaux* (panels). These could be placed side by side, creating a vast, unbroken field of imagery to be viewed as an unfolding entirety rather than a sequence. Four panels appeared in the photographs, and a letter written to one of his dealers, the Bernheim-Jeune brothers, in November confirms that some were near completion.

But Monet's spirits fell near the end of the year when his son returned home, traumatized by the horrors he had seen at Verdun. On 14 December Monet told Sasha Guitry that he now feared that he had ruined the panels in his attempts to improve them. He faced the new year with shaken confidence, writing to Geoffroy, "I no longer have the courage to do anything." On 16 February, his

The Japanese Bridge, 1918–1924, Musée Marmottan–Monet, Paris.

As his sight rapidly deteriorated, Monet worked from memory, and, as he told one reporter in 1921, "I will paint almost blind, as Beethoven composed nearly deaf." During this time, he painted an extended series of the Japanese bridge. The variations among the pictures are startling, and some feature a harsh, vibrating palette and thick, slashing brush strokes.

dear friend Mirbeau died. Monet now felt old, impaired by his failing powers and impending mortality.

Monet now saw the *Grandes Décorations* as an insurmountable challenge and he refused to allow visitors to enter his studio. Durand-Ruel's sons, Georges and Joseph, asked permission to photograph the works, but Monet denied the request, cautioning them that it was "useless" to talk about the prospect of selling the panels. But on 11 November, Monet relented, and the photographs reveal the advanced state of the project. Twelve panels, roughly six and a half feet high and fourteen feet wide, appear with temporary frames on the upper and lower edges. Easels mounted on wheeled dollies allowed Monet to arrange the panels so that the imagery flowed from canvas to canvas, as if it were a vast, single surface. The groups were defined by motifs: willows with their leaves cascading over the water, agapanthus, and iris. Monet allowed the Durand-Ruel brothers to take their photographs, but he warned them that he would not consider releasing any of the paintings – the panels or the studies. He insisted that he needed them all to continue his work. Other visitors now came to the studio, including the Bernheim-Jeune brothers, and Monet resumed his work with intensified energy.

A GIFT TO THE NATION

On 12 November 1918, Monet sent a letter to Clemenceau, announcing his desire to give a gift to the nation: "I am on the verge of finishing two decorative panels which I want to sign on Victory day and am writing to ask you if they could be offered to the State with you acting as intermediary." Throughout the war, Clemenceau had presided over the Armed Forces Committee of the Senate, and his decisive leadership had earned him the nickname "The Tiger." In March 1918, the Allies had stopped the German forces just short of Paris, allowing them to launch the successful counter-offensive that led to the resolution of the conflict. The Armistice of World War I was signed on 11 November, and a week later, Clemenceau made the journey to Giverny. On Monet's urging he selected the two works, one panel featuring water lilies and another with willows. But in the course of their conversation, Clemenceau convinced Monet to consider a more substantial donation: the complete *Grandes Décorations* housed in an appropriate setting as a public monument in Paris. Geoffroy, who accompanied Clemenceau to Giverny, observed that Monet looked ten years younger, and he characterized the intended gift as "a bouquet of flowers to honour victory in war and the conquest of peace."

The House Seen From the Rose Garden, 1922–1924, Musée Marmottan-Monet, Paris.
After the third operation on his right eye, Monet experienced an imbalance in his colour perception. This was not an uncommon reaction, but at first he saw all tones tinged with yellow. Within months, blue and violet came to dominate, which was more typical as the aftermath of the operation. He continued to paint, relying on his memory of particular pigments, but the effects of his cyanopsia are evident in the dramatic blue palette in this work.

Nearly thirty years earlier, in his review of the exhibition of the *Rouen Cathedral* series, Clemenceau had challenged the then President of France to purchase the pictures and preserve the ensemble in its entirety for the nation. Now, as Premier of France, he had the means to give his friend the opportunity to realize his design for the *Grandes Décorations*. Over the next two years, Clemenceau worked to raise the political support and allocate the necessary funds for the project, while Monet considered the selection

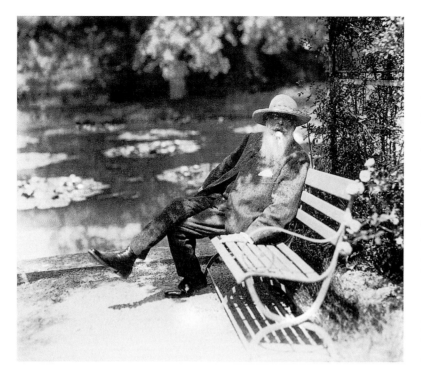

of twelve panels for the final ensemble. The practicality of installing the works in an interior space presented new problems. To demonstrate his design, Monet had arranged the panels on their wheeled dollies to encircle Clemenceau, who was dazzled by the effect, but exclaimed, "the door, that's what bothers me . . . ; instead of coming in through the door you should be able to be deposited by some kind of elevator right into the middle of the studio!" Monet then began yet another series of panels in a horizontal format, featuring branches of blossom-laden wisteria against a background of subtly modulated sky. He proposed to install them as a frieze above the intervening doorways, so that the flow of imagery continued without interruption.

The new work distracted him from his task of selecting the main panels, and soon, he embarked on several new series, including unrelated depictions of water lilies and views of the Japanese bridge. Clemenceau quickly realized that it would be difficult to force Monet to part with his work, for the aged artist insisted that he would not release any of the panels until he was thoroughly satisfied with the complete ensemble.

In January 1920, Clemenceau was defeated in his bid for the Presidency of France. Although his influence was reduced, he continued to promote the project with the support of Etienne Clémentel, formerly the Minister

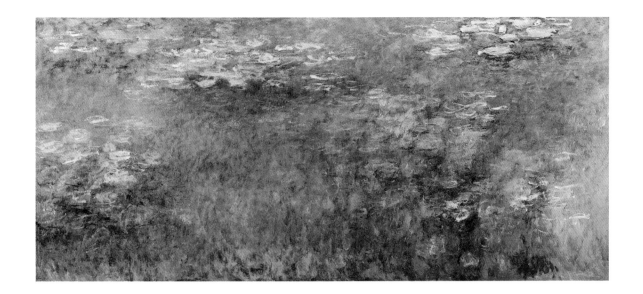

ABOVE *Water Lilies,*
c. 1920–1926, Nelson-
Atkins Museum of Arts,
Kansas City, Missouri.
Monet painted more
than forty panels in the
process of creating his
Grandes Décorations. In his
exploration of colour and
light effects, the persistence
of motifs, such as the
agapanthus, reveals that
he also experimented by
combining different panels.
While the delicate lavender
tones of this painting vary
from the predominantly
brighter blue of the left
and central panels of the
original triptych, the
course of flowing water
and the patterns of the
lilies connect the three
canvases. These have now
been dispersed to different
museums.

of Industry and Commerce. That June, the Ministry of Fine Arts proposed the construction of a rotunda on the grounds of Hôtel Biron, the former home and studio of the sculptor Auguste Rodin, who had willed it to the nation upon his death in 1916. Late that summer, Louis Bonnier, a prominent architect, was hired. After close consultation with Monet, he produced a design for a circular interior, accessible through two narrow doors flanking a vestibule. Bonnier's plan, drawn up that December, suggested an arrangement of panels: a suite of *Green Reflections* between the doors, with *Wisteria* above; and, moving clockwise around the room, suites of *Clouds, Three Willows,* and *Agapanthus.*

Throughout the early months of 1921, the Parliament wavered on its support for the project, and in April Bonnier's plan was rejected as too expensive. Paul Léon, head of the Ministry of Fine Arts, proposed that the works be installed in an existing building in Paris, suggesting either the Jeu de Paume or the Orangerie in the Tuileries. Clemenceau pressed Monet to accept this compromise, and he reluctantly agreed to the installation of the *Grandes Décorations* in the Orangerie, which required extensive modifications. The long narrow space would provide two elliptical rooms, and throughout the autumn, Monet proposed additional works to fill the extra space, raising the number from twelve to twenty. In December, Louis Bonnier was dismissed from the project and replaced by Camille Lefèvre, the architect at the Louvre. In response to the expansion of the plan, which grew to twenty-two panels in January 1922, Monet felt compelled to retouch his work, adjusting the relationship between

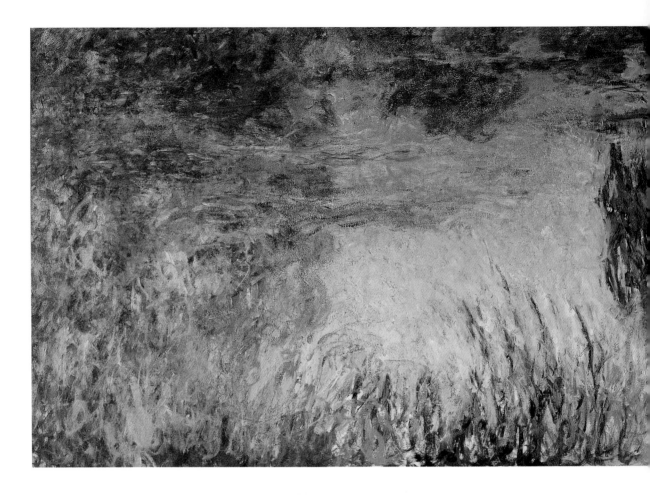

the individual panels and the harmonies between the extended suites. On 12 April 1922, Monet signed the Act of Donation, which was finalized in June. That summer, despite his age and his waning energy, Monet worked with intensity, declaring, "I want to paint everything before my sight is completely gone."

"MY POOR EYESIGHT"

After the initial diagnosis of his cataracts, Monet insisted that his vision had stabilized, but by 1919, he could no longer deny the effects of the deterioration. For years, he had avoided the brilliant light of midday, but now even the shade of the parasol did not protect his limited vision from the glare of lateral light. In 1920, he explained to the journalist François Thiebault-Sisson that he could only tolerate natural light during the early morning and evening hours and that he painted from the impressions in his memory, rather than his observations. On 11 August 1922 he wrote to

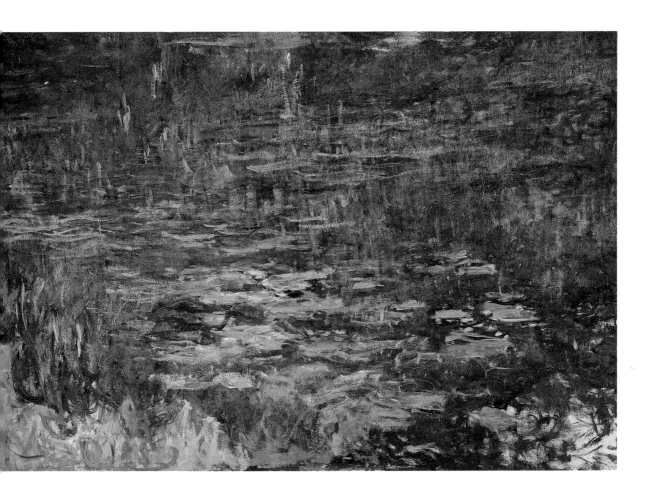

Sunset, Grandes Décorations (detail), 1920–1926, Orangerie, Paris. Monet captured the dramatic light of sunset in his muted palette, heightened with a shimmer of yellow that fades into orange and rose. Under the darkening sky, the lilies close and the waters turn opaque. The angle of the setting sun is now too low to cast reflections on the water's still surface, but the last bright beams of illumination glaze part of the pond in a warm, golden glow.

the Bernheim-Jeune brothers that "my poor eyesight makes me see everything in a complete fog." In the autumn, under pressure from Clemenceau, Monet was examined by the prominent ophthalmologist Dr. Charles Coutéla, a personal friend of the old statesman. The diagnosis was dire. Monet retained only ten percent of the vision in his left eye; his right was blind. He resisted the prescribed operation on his right eye, insisting that eye drops would relieve the condition, but he finally relented in the new year. The procedure required two operations, on 10 January and 31 January, and Monet proved to be a difficult patient. But his robust health aided his swift recovery, and Coutéla released Monet from the eye clinic on 17 February.

Complications required a third operation in June 1923, and although Coutéla declared the procedure was successful, Monet was dissatisfied with the results. Later in the month he reported

Green Reflections, Grandes Décorations (detail), 1920–1926, Orangerie, Paris. The random movement of the lilies on the water convinced Monet of the infinite variety of his motif. Here, his glance skims across the surface. His angle of vision is low, allowing the water to flow from edge to edge with no indication of the banks to limit its motion. The cool palette evokes a refreshing atmosphere as the reflections of the shady trees that enclose the pond play in hues of green across its surface.

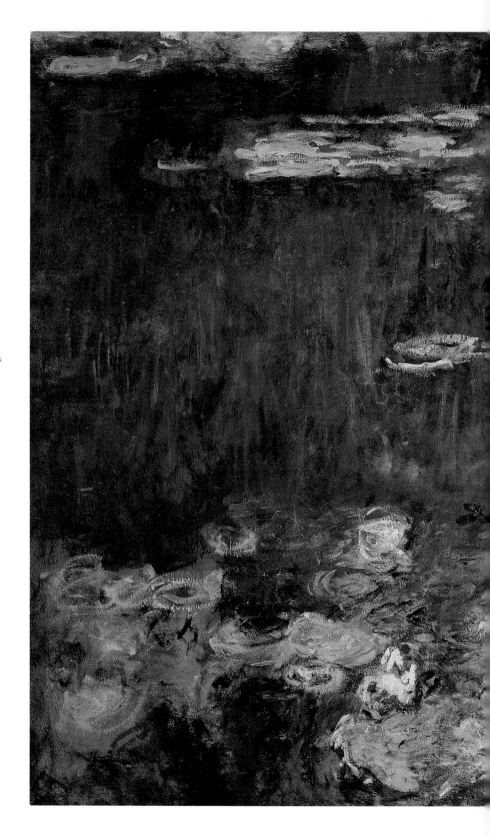

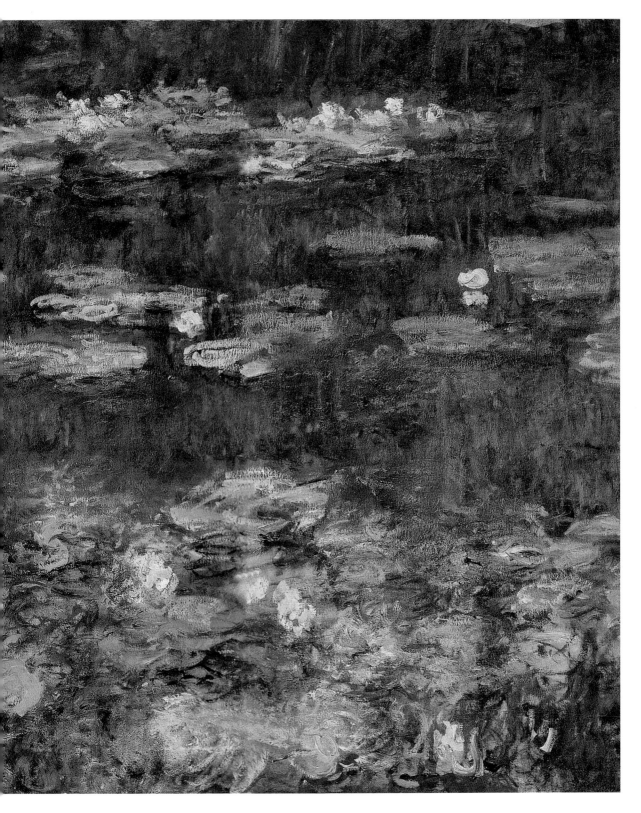

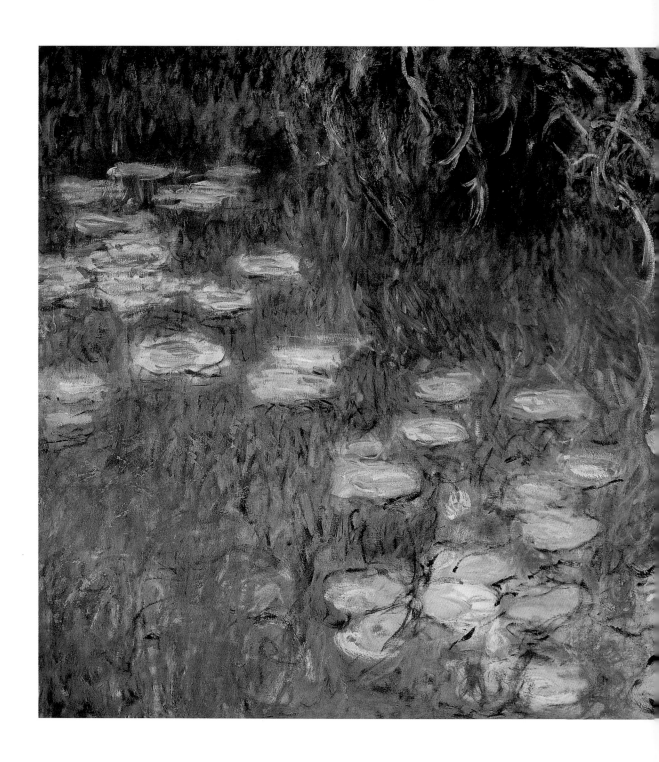

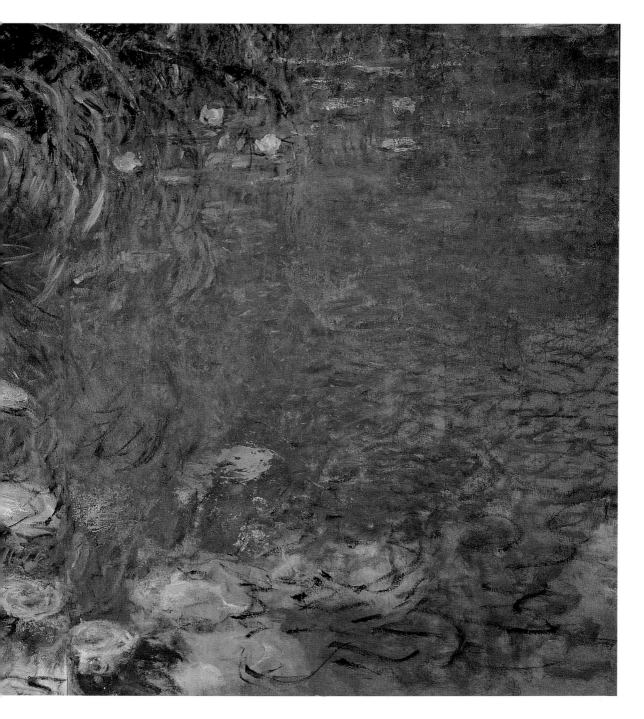

Morning, Grandes Décorations (detail), 1920–1926, Orangerie, Paris.

In *Morning*, the verdant banks of the pond frame the shifting waters. As the sun rises, the lilies begin to open, and their bright colours sparkle like jewels on the pale green pods that cluster near the pond's edge. The rhythm of the flowing waters unites the four panels that compose the suite *Morning*. The lilies rise on the gentle crests over the subtle reflections that in the early hours of the day begin to dapple the surface of the pond.

to Coutéla that he was able to read a bit, but could not see either in daylight or at a distance. The spectacles he now wore were of no help, and he regretted having what he called "the fatal operation." "Excuse me for being so frank," he wrote, "I think it's criminal to have placed me in such a predicament." Over the summer, Monet developed xanthopsia, an imbalance of colour perception which tinged everything he saw in glaring yellow. This was not an uncommon aftermath of a cataract operation; tinted spectacles were used to make the adjustment, but Monet could not tolerate seeing his world so drastically altered. He wrote to Clemenceau on 23 August, "I would prefer to be blind and keep the memories of the beauties which I have always seen."

As the months passed, Monet's xanthopsia abated, giving way to the more common condition known as cyanopsia, which altered his perceptions from yellow to blue. His left eye continued to deteriorate, but when Clemenceau suggested he try another operation, Monet retorted, "unless I find a painter, of whatever kind, who's had the operation and can tell me that he can see the same colours as he did before, I won't allow it."

Water Lily Pond with Irises, 1920–1926, Kunsthaus, Zurich.
In the course of exploring his concept for the *Grandes Décorations,* Monet painted panels featuring his favourite flower, the iris. He used a dazzling palette, ranging from the rich purple shadows on the water to the golden reflections of the sunset. The lithe forms of the deep violet iris plants are brushed in with a calligraphic stroke.

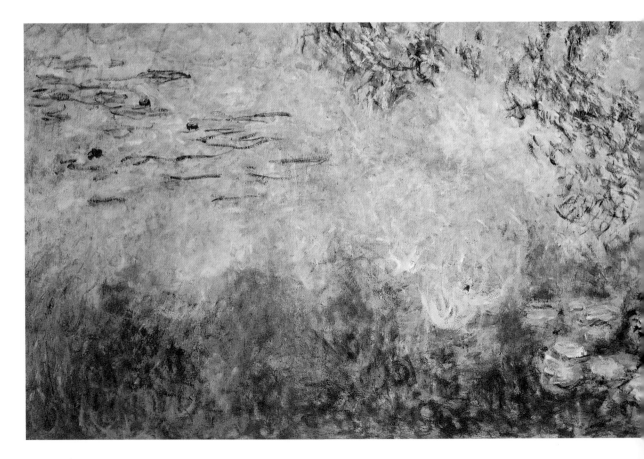

By November, Monet wrote to Clémentel that despite his impairments, he had taken up his brushes again.

Over the subsequent months, Coutéla attempted to alleviate the colour imbalance with different spectacles, but in the spring of 1924, the painter André Barbier convinced Monet to experiment with a new type of lens developed in Germany. The oculist Dr. Jacques Mawas came to Giverny to fit Monet with a set of Zeiss lenses. After examining Monet, Mawas asked him how he still managed to paint. Monet answered, "By the tubes of paint I use." He explained that he no longer saw red or yellow, but recalled their qualities: "I know that red and yellow are on my palette, and a special green and a certain violet. I cannot see them as I used to, and yet I remember exactly what colours they used to make."

After a series of different combinations, Mawas provided Monet with a suitable set of spectacles. By the end of the year he was again at work on the *Grandes Décorations*. But his left eye continued to deteriorate. This altered his depth perception and eliminated what little distance vision he had left. Monet found it impossible to step back from his work to take

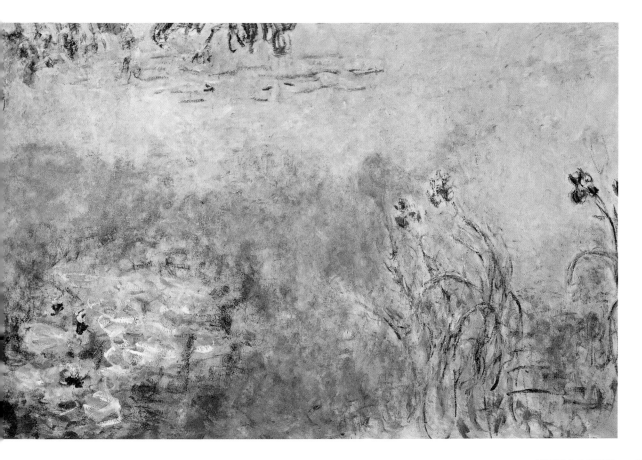

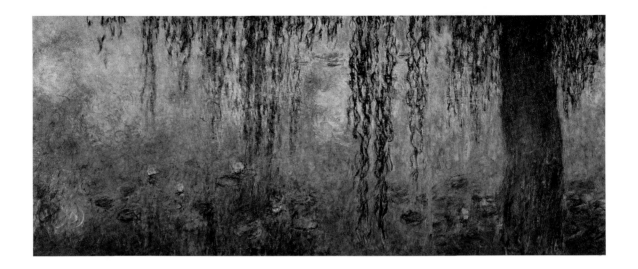

in the full effect. Mawas was called to Giverny for another examination. The cyanopsia had not abated, and Mawas adjusted the lens prescription for greater precision. Mawas then tried a simple solution to deal with the blindness in Monet's left eye. He covered the eye with a black lens and Monet enjoyed his first significant improvement. As he waited for his new spectacles in July 1925, Monet wrote to Barbier, "I am working as never before, am satisfied with what I do, and if the new glasses are even better, my only request would be to live to be one hundred."

The struggle to salvage Monet's vision delayed his progress on the *Grandes Décorations*. He was unable to work throughout most of the year of 1923, yet by November, he believed that he could still meet the original deadline of April 1924. But the impairment of his colour perception undermined Monet's confidence, and he hesitated to work on the panels for fear that he would ruin them. The deadline passed, and late in the year, he informed Paul Léon that he could not fulfill the agreement. When Clemenceau received the news he raged: "I don't care how old, how exhausted you are and whether you are an artist or not. You have no right to break your word of honour, especially when it was given to France." Clemenceau threatened to end their friendship, plunging Monet into an even deeper depression.

In the spring of 1925, the prospect of the new Zeiss spectacles restored Monet's hope, as did a reconciliation with Clemenceau. That summer, fitted with his new corrective lenses, Monet returned to his work, and in November 1925, he announced that the panels would be finished by spring. In the new year, Monet promised Clemenceau that the first set

Morning with Willows, Grandes Décorations (detail), 1920–1926, Orangerie, Paris. While the first room of the *Grandes Décorations* explores the mutability of the water through the course of the day, the second room escorts the viewer on a walk around the pond. Willows appear throughout the ensemble. Their twisting trunks rise at random, like irregularly spaced columns, and their drooping branches descend down the canvas like ragged veils. The pond lies beyond the willows, and on its shining surface is an infinite field of reflection, where the glassy water and the cloud-strewn sky merge into a single, shimmering image.

of panels were ready for delivery; he was simply "waiting for the paint to dry." But Clemenceau did not press him. Monet had become frail and his health was declining. The death of his friend Geoffroy on 4 April left him feeling "old and weak." When Clemenceau visited to comfort Monet, he observed: "The panels are finished and he will not touch them again. But he does not have the strength to let them go."

As the summer passed, Monet's appetite waned and his loss of weight alarmed Blanche. His persistent coughing compelled him to stop smoking, and late in August, when Blanche forced him to see a physician, an x-ray revealed that he had pulmonary disease and a lesion on one lung. He had no strength to work, but, with Blanche's reluctant assistance, he destroyed at least sixty canvases stored in the studio. He rallied briefly in October, writing to Léon that he was working "in very small doses," but by November, he was too weak to leave his bed. Clemenceau visited every Sunday, and Monet told him he had just received a shipment of Japanese lily bulbs. The prospect of their beauty comforted him, but also reminded him of his fate. He told Clemenceau, "You will see all that in the spring. I shall not be there."

Monet died of pulmonary sclerosis on 5 December 1926 at the age of eighty-six. Before his death he instructed his family that he wanted a simple funeral: no religious service and no flowers. "Bury me as if I were a local man. And you, my relatives, only you shall walk behind my coffin . . . Above all, remember that I want neither flowers nor wreaths. Those are vain honours. It would be a sacrilege to plunder the flowers of my garden for an occasion such as this." On 8 December, a small cortege of mourners left the house in Giverny. His gardeners served as his pall bearers, and he was buried in the Hoschedé family tomb in the churchyard next to Alice. His wishes were followed. The only tribute placed on his coffin was a sheaf of wheat.

LAST LEGACY

Late in December, workmen removed the twenty-two panels that Monet had selected for the *Grandes Décorations* from his studio. They were installed in the Orangerie the following spring. According to Monet's instructions, the canvases were removed from their stretchers and affixed directly to the curving walls. It was Monet's wish that the paintings not be varnished and that natural light be the main source of illumination for the galleries.

On 17 May 1927, a small ceremony marked the official opening of the *Grandes Décorations.* The two rooms, with their panoramic paintings, transported the visitor from Paris to Monet's garden. In the first, the volatile effects of changing light played upon the shimmering waters in a series of panels that portrayed *Sunset, The Clouds, Green Reflections,* and *Morning.* The second evoked the natural splendour of the verdant banks of the pond with willows as the dominant motif, including *The Water Lily Pond with Willows, Two Willows,* and *Bright Morning with Willows.* Monet had dedicated his life to capturing the fleeting effects of nature, and in

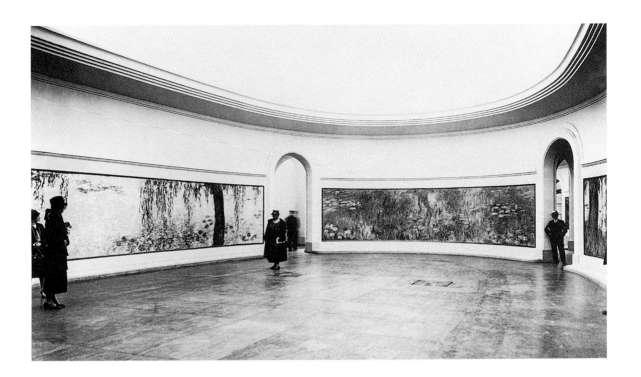

A View into the Second Room of the Orangerie, c. 1930, private collection. After Monet's death in December 1926, the twenty-two panels of the *Grandes Décorations* were removed from his studio and transported to the Orangerie in Paris. The hushed atmosphere of the gallery conveyed Monet's vision of the *Grandes Décorations* as a serene refuge, evoking "the restful sight of those still waters."

the *Grandes Décorations* he testified to his conviction that nature's infinite mystery and eternal beauty transcended the span of human life and the scope of human comprehension.

When Monet was young, Émile Zola had praised his power to portray life exactly as he saw it, predicting that his profound sympathy for his surroundings would endure as the touchstone for his art. As the years passed, Monet fulfilled Zola's prediction, finding the greatest inspiration for his art in the sanctuary of his own garden. Monet had defined his art simply as a means to express himself before nature, convinced that his reverence for natural wonder found its ultimate declaration in his painting rather than his words. He once attempted to explain the force that fuelled his art to Clemenceau, disdaining all philosophies that tried to reduce the world to the realm of intellectual understanding. He claimed that the observation of natural phenomena had brought his sensibilities into harmony with the world. "All I did," he said, "was to look at what the universe showed me, to let my brush bear witness to it."

For Monet, this final work, the *Grandes Décorations,* encompassed the observations of a lifetime. In "the restful sight of those still waters" was the revelation of the resonance between art and nature that Monet sought throughout his career and found, at last, painting his garden.

THE GARDEN TODAY

During Monet's lifetime, a walk in his garden was regarded as a special privilege, providing a view into the painter's most intimate inspiration. But at the same time, insightful visitors recognized the painter's artistic vision in his garden, as if nature was a medium that he had mastered as well as pigment on canvas. After his visit to Giverny in the summer of 1901, journalist Arsène Alexandre observed, "Everywhere you turn — around your feet, above your head, at chest level — there are lakes, garlands, and hedges of flowers, whose colour harmonies are at once improvised, yet calculated, and which renew themselves each season." Today, visitors to Monet's garden can enjoy this natural spectacle, little aware that for decades, the garden fell into neglect.

Upon Monet's death, his son Michel inherited the Giverny property. But it was Monet's stepdaughter Blanche who lived there, and from 1927 to her death in 1947, she struggled with the assistance of a single gardener to tend the sprawling grounds. After her death, the garden lay neglected. In 1960, Michel died in a car accident and bequeathed the property to the French nation. The house and garden had fallen into dire disrepair, and it required an international fundraising campaign to carry out the restoration. For two decades, the combined efforts of patrons, scholars, engineers, and gardeners worked to bring Monet's vision back into flower. The restored garden opened to the public in September 1980, allowing countless appreciative visitors to share the spirit of Monet's art in his garden.

Today, the garden restores the spirit of the original rather than replicates its exact appearance during Monet's lifetime. Although the present plantings were selected with regard to contemporary photographs and the recollections of visitors who saw the garden in its former glory, careful adjustments have been made. Many of the original bulbs and seeds are no longer available, and changes, such as widened paths reinforced with cement and brick borders, were necessary to protect the grounds. But Monet's vision has been preserved, and what was once enjoyed by the painter and a few select guests is now shared with eager visitors from every corner of the world.

CLAUDE MONET'S HOUSE AND GARDENS

Fondation Claude Monet, Rue Claude Monet, 27620 Giverny.
Tel: (0)2 32 51 28 21 www.fondation-monet.com
Open daily from 9.30 am to 6 pm from 1 April to 31 October.
On Mondays the gardens are open only to people wishing to paint.

MUSÉE D'ART AMÉRICAIN, GIVERNY

99 Rue Claude Monet, 27620 Giverny.
Tel: (0)2 32 51 94 65
Open daily from 10 am to 6 pm from 1 April to 31 October.
The American Art Museum in Giverny holds a collection of work by American Impressionist painters, who were greatly influenced by their time in France and by the work of Claude Monet. The Museum also mounts special exhibitions and holds a range of cultural events.

THE GIVERNY GARDEN

These plans show the layout of Monet's flower and water gardens. Changes have been made since the painter's death, such as the underground path which allows access from the flower garden to the water garden. But the preservation of the general plan, as well as the annual renewal of the garden's transitory beauty, allow new generations to share in Monet's passion for cultivated nature.

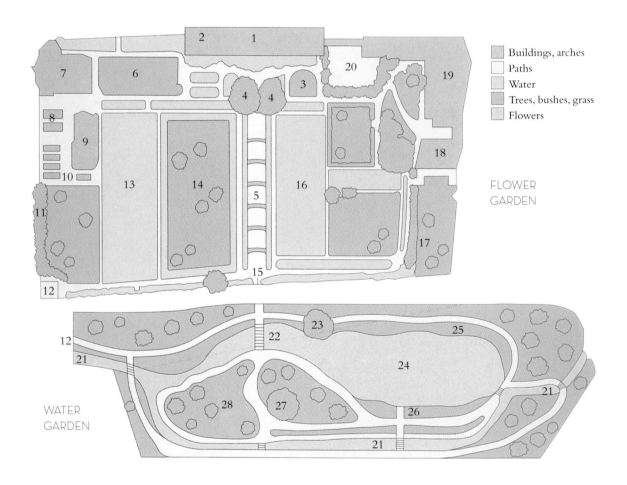

Buildings, arches
Paths
Water
Trees, bushes, grass
Flowers

FLOWER GARDEN

WATER GARDEN

1	House
2	Monet's bedroom, above first studio
3	Crabapple tree
4	Twin yews
5	Grande Allée with rose arches
6	Pleached limes
7	Second studio (1897)
8	Small greenhouses
9	Large greenhouse
10	Warm frames
11	Hedge of horse chestnut
12	Entrances to underground passage
13	Monochromatic and polychromatic flowerbeds
14	Lawn with roses, fruit trees, and square flowerbeds
15	Former main gate
16	Paintbox beds
17	Espaliered apple trees
18	House formerly lived in by Monet's head gardener
19	Third studio (1915)
20	Chicken and turkey yard
21	The diverted River Ru
22	Wisteria-covered Japanese bridge
23	Weeping willow
24	Water lily pond
25	Wisteria
26	Rose arches
27	Copper beech and tree peonies
28	Bamboo thicket

WHO'S WHO

ALEXANDRE, ARSÈNE (1859–1937)
French writer and art historian, who expressed his strong support for Monet in many articles and in a book written during the painter's lifetime.

BAZILLE, FRÉDÉRIC (1841–1870)
French painter, who studied at Gleyre's studio in Paris with Monet, Renoir, and Sisley. Bazille shared a close friendship with Monet until he was killed in action in the Franco-Prussian war.

BERNHEIM-JEUNE, JOSSE (1870–1941) and GASTON (1870–1953)
French art dealers, whose Parisian gallery specialized in Impressionist and Post-impressionist art in the early twentieth century. Monet worked through the Galerie Bernheim-Jeune in addition to his representation by Durand-Ruel.

BOUDIN, EUGÈNE (1824–1898)
French marine landscape painter, who encouraged Monet to paint out of doors in his early career. He exhibited in the first Impressionist exhibition held in 1874.

BRECK, JOHN LESLIE (1860–1899)
American painter, who lived and worked in Giverny for a time and enjoyed a brief friendship with Monet and his family.

BREUIL, FÉLIX
Monet's head gardener and author of an article on varieties of iris. He came to work at Giverny in the early 1890s and remained with Monet until the end of World War I.

BUTLER, THEODORE (1861–1936)
American painter, who settled in Giverny and became acquainted with the Monet family. He married Suzanne Hoschedé, one of Monet's stepdaughters in 1882, and after her death married her elder sister, Marthe in 1900.

Green Reflections, Grandes Décorations (detail), 1920–1926

CAILLEBOTTE, GUSTAVE (1848–1894)

French painter and collector, who purchased Impressionist paintings. One of Monet's close friends, he shared his keen interest in gardening.

CASSATT, MARY (1845–1926)

American painter, who settled permanently in Paris in 1874. An encounter with Edgar Degas drew her into the Impressionist circle and she was the only American to exhibit works in the Impressionist exhibitions.

CÉZANNE, PAUL (1839–1906)

French painter and one of the most important figures of late nineteenth-century art. He visited Monet at his home in Giverny.

CLEMENCEAU, GEORGES (1841–1929)

Publisher and statesman, who founded *La Justice* in 1881 and served as Premier of France from 1906 to 1909 and from 1917 to 1920. One of Monet's closest friends from the 1880s, Clemenceau shared Monet's passion for gardening and took an active role in the state sponsorship of the *Grandes Décorations*.

DONCIEUX, CAMILLE-LÉONIE (1847–1879)

Monet's first wife, whom he married in 1870, and the mother of his sons Jean and Michel. Camille modelled for Monet throughout their life together and appears in paintings such as *Women in the Garden* (1866-1867) and *The Artist's House at Argenteuil* (1873).

DURAND-RUEL, PAUL (1831–1922)

French art dealer based in Paris, who represented Monet throughout his career. He organized many of Monet's major exhibitions, including the exhibition at the American Art Gallery in New York City in 1886 that introduced his work to the American public. Durand-Ruel's sons Georges and Joseph joined him in his business.

FRIESEKE, FREDERICK CARL (1874–1939)

American painter, who lived and worked in Giverny for 14 years. Although he rented the house next door to Monet's house, there is no record of any contact.

GEOFFROY, GUSTAVE (1855–1926)

French writer and art critic, who had a long and close relationship with

Monet and shared his love of gardening. He published an authorized biography of Monet in 1922.

GLEYRE, CHARLES (1808–1874)

Swiss-born painter, who spent much of his life in Paris. He ran a private studio where he taught many of the greatest Impressionists, including Bazille, Monet, Renoir, and Sisley.

HIROSHIGE, ANDO (1797–1858)

Japanese painter of the last generation of *ukiyo-e* masters whose work Monet admired and collected.

HOKUSAI, KATSUSHIKA (1760–1849)

Japanese painter, print maker, and book illustrator of the *ukiyo-e* school whose work Monet collected.

HOSCHEDÉ-MONET, ALICE (?1844–1911)

Born Alice Raingo, she became the wife of Ernest Hoschedé and mother of his six children. The Hoschedé family sought refuge with Monet when Ernest became bankrupt. Alice nursed Monet's wife Camille, and became Monet's life companion after her death. After Hoschedé's death in 1892, Alice became Monet's second wife.

HOSCHEDÉ-MONET, BLANCHE (1865–1947)

Second daughter of Monet's second wife, Alice. An accomplished *plein-air* painter, she married Jean, Monet's eldest son.

HOSCHEDÉ, ERNEST (1837–1892)

Department store owner, who commissioned Monet to paint some decorative panels for his château in Montgeron. Hoschedé lived well above his means and when he became bankrupt, he turned to Monet for help and shelter for his family.

HOSCHEDÉ-SALEROU, GERMAINE (1873–1969)

Youngest daughter of Monet's second wife, Alice.

HOSCHEDÉ, JACQUES (1869–?)

Elder son of Monet's second wife, Alice.

HOSCHEDÉ, JEAN-PIERRE (1877–1961)

Younger son of Monet's second wife, Alice, Jean-Pierre was the author of the memoir *Claude Monet, ce mal connu* (1960).

HOSCHEDÉ-BUTLER, MARTHE (1864–?)

Eldest daughter of Monet's second wife, Alice. Marthe married Theodore Butler after the death of her sister Suzanne, Butler's first wife.

HOSCHEDÉ-BUTLER, SUZANNE (1868–1899)

Third daughter of Monet's second wife, Alice. She married Theodore Butler and gave birth to two children – James in 1893 and Alice, known as Lili, in 1894. Among his many stepdaughters, she was Monet's favourite model.

MALLARMÉ, STÉPHANE (1842–1898)

Symbolist poet, who became a close friend of several of the Impressionists, including Renoir, Edgar Degas, Berthe Morisot, and Monet.

MANET, ÉDOUARD (1832–1883)

French painter, whose frank and direct approach to contemporary subjects had a profound effect on the artists who formed the Impressionist circle. Manet never exhibited with the Impressionists, but he formed a strong bond with Monet, especially during his stay in Argenteuil, when the younger painter encouraged Manet to paint out of doors.

MARX, ROGER (1859–1913)

Journalist and art collector, who was instrumental in bringing Cézanne's work to critical acceptance and was a strong advocate of Monet's late series work, notably *Les Nymphéas*.

MIRBEAU, OCTAVE (1848–1917)

Novelist and playwright. Mirbeau was a regular visitor to Monet's house at Giverny and shared the artist's passion for gardening.

MONET, CLAUDE-ADOLPHE (1800-?)

Monet's father, who ran a modest business in Ingouville, a suburb of Le Havre.

MONET, JEAN (1867–1914)

Monet's eldest son. Married Blanche Hoschedé in 1897.

MONET, MICHEL (1878–1966)
Monet's second son.

PERRY, LILLA CABOT (1848–1933)
American painter who, with her family, resided for a while at Giverny and enjoyed a lasting friendship with Monet and his family.

PISSARRO, CAMILLE (1830–1903)
French painter and one of the leading Impressionists. Exhibited at all eight Impressionist exhibitions. Pissarro met Monet in London in 1871 and introduced him to Paul Durand-Ruel.

PROUST, MARCEL (1871–1922)
French writer and a leading literary figure.

RENOIR, PIERRE AUGUSTE (1841–1919)
French painter and one of the leading Impressionists. Renoir exhibited his work at the first three Impressionist exhibitions and studied at Gleyre's studio where he met Sisley and Monet. He remained in contact with Monet and sometimes painted with him.

ROBINSON, THEODORE (1852–1896)
American painter, who lived and worked in Giverny for a time and had a close friendship with Monet.

SARGENT, JOHN SINGER (1856–1925)
American painter and successful society portraitist. He met Monet in Paris and visited him during his early years in Giverny where he experimented with *plein-air* painting.

SISLEY, ALFRED (1839–1899)
Impressionist painter, born in France of English parents. Studied with Gleyre with Renoir and Monet and remained close to Monet.

ZOLA, ÉMILE (1849–1902)
French novelist with a zeal for social reform. An outspoken art critic in the 1860s and 1870s, Zola gave Monet his first public support and they remained friends.

SELECT BIBLIOGRAPHY

A Day in the Country: Impressionism and the French Landscape. Exh. cat. Los Angeles: Los Angeles County Museum of Art, 1984.

GERDTS, WILLIAM H. *Lasting Impressions: American Painters in France 1865–1915*. Exh. cat. Evanston, Illinois: Terra Foundation for the Arts, 1992.

GERDTS, WILLIAM H. *Monet's Giverny: An Impressionist Colony*. New York: Abbeville Press, 1993.

GOMES, ROSALIE. *Impressions of Giverny: A Painter's Paradise 1883–1914*. San Francisco: Pomegranate Art-Books, 1995.

HOUSE, JOHN. *Monet: Nature into Art*. New Haven and London: Yale University Press, 1986.

MAYER, STEPHANIE. *First Exposure: The Sketchbooks and Photographs of Theodore Robinson*. Giverny: Musée d'Art Américain, Giverny/Terra Foundation for the Arts, 2000.

MICHELS, HEIDE and GUY BOUCHE. *Monet's House: An Impressionist Interior*. London: Frances Lincoln, 1997.

Monet: A Retrospective (ed. Charles F. Stuckey). New York: Hugh Lauter Levin Associates, Inc., 1985.

Monet by Himself: Paintings, drawings, pastels, letters (ed. Richard Kendall). Boston: Little Brown and Company, 1989.

Monet's Years at Giverny: Beyond Impressionism. Exh. cat. New York: Metropolitan Museum of Art, 1978.

ORR, LYNN FEDERLE. *Monet: Late Paintings of Giverny from the Musée Marmottan.* Exh. cat. San Francisco: San Francisco Fine Arts Museums, 1994.

REWALD, JOHN. *The History of Impressionism.* New York: The Museum of Modern Art, 1973.

RUSSELL, VIVIAN. *Monet's Garden: Through the Seasons at Giverny.* London: Frances Lincoln, 1995.

RUSSELL, VIVIAN. *Monet's Water Lilies.* London: Frances Lincoln,1998.

SAGNER-DUCHTING, KARIN. *Monet at Giverny.* Munich: Prestel, 1999.

STUCKEY, CHARLES F. *Claude Monet 1840–1926.* Exh. cat. Chicago: The Art Institute of Chicago, 1995.

STUCKEY, CHARLES F. *Monet: Water Lilies.* New York: Hugh Lauter Levin Associates, Inc.,1988.

TUCKER, PAUL HAYES. *Monet at Argenteuil.* New Haven and London: Yale University Press, 1982.

TUCKER, PAUL HAYES. *Claude Monet: Life and Art.* New Haven and London: Yale University Press, 1995.

TUCKER, PAUL HAYES. *Monet in the '90s. The Series Paintings.* Exh. cat. Boston: Museum of Fine Arts, 1989.

TUCKER, PAUL HAYES. *Monet in the 20th Century.* Exh. cat. New Haven and London: Yale University Press, 1998.

WILDENSTEIN, DANIEL. *Monet. Catalogue Raisonné.* 4 vols. Cologne: Benedikt Taschen, 1996

INDEX

Page numbers in *italic* refer to illustration captions

ACKNOWLEDGMENTS

PHOTOGRAPHIC ACKNOWLEDGMENTS

The Publishers have made every effort to contact holders of copyright works. Any copyright-holders we have been unable to reach are invited to contact the Publishers so that a full acknowledgment may be given in subsequent editions. For permission to reproduce the paintings and archive photographs on the following pages and for supplying photographs, the Publishers thank those listed below.

akg, London: 14–15; 125; 116–117; 122–123

akg, London / Erich Lessing: 61; 152; 144–145; 146–147; 148–149

Archives of American Art, Smithsonian Institution (Lilla Cabot Perry Papers 1898–1909): 48; 52

Archives Toulgouat/ARTEPHOT, Paris: 93

The Art Institute of Chicago (photographs courtesy of The Art Institute of Chicago): 21 (Mr and Mrs Martin A. Ryerson Collection, 1933.1153); 70 & 76–77 (Mr and Mrs Martin A. Ryerson Collection, 1933.1157)

Bridgeman Art Library: 97 (Los Angeles County Museum of Art); 98; 105 (Rafael Valls Gallery, London); 108–109 (National Academy of Design, New York); 126–127 (Rafael Valls Gallery, London); 115 (Victoria and Albert Museum, London)

Bridgeman Art Library/Roger-Viollet, Paris: 13; 60; 135; 155

Foundation E.G. Bührle Collection: 37

© Christie's Images Ltd 2001: 44; 112

Corbis Sygma: 12; 78

Dallas Museum of Art: 1 & 84 (gift of the Meadows Foundation Incorporated); 72 (private collection)

Courtesy George Eastman House: 127 above; 142

Giraudon: 29; 34 & 40–41; 138–139; 141

© 2001 Kunsthaus Zürich. All rights reserved: 150–151

Los Angeles County Museum of Art: 57 (Mrs Fred Hathaway Bixby Bequest). Photograph © 2000 Museum Associates/LACMA

The Metropolitan Museum of Art: 26 (bequest of Joan Whitney Payson, 1975. (1976.201.14) Photograph © 1990 The Metropolitan Museum of Art); 30 (The Walter H. and Leonore Annenberg Collection, Partial

Gift of Walter H. and Leonore Annenberg, 2000. (2000.93.1) Photograph © 1994 The Metropolitan Museum of Art)

Musée d'Art et d'Histoire Marcel-Dessal, Dreux: 134

Musée Clemenceau, Paris: 136

Courtesy Museum of Fine Arts, Boston (reproduced with permission. © 2001 Museum of Fine Arts, Boston. All Rights Reserved): 55 (gift of Dr G.S. Amsden); 74–75 (gift of Edward Jackson Holmes, 39.804); 80–81 (bequest of Alexander Cochrane, 19.170)

© 2001 Board of Trustees, National Gallery of Art, Washington: 22–23 (partial gift of Janice H. Levin, in honour of the 50th anniversary of the National Gallery of Art); 32–33 (Ailsa Mellon Bruce Collection); 62–63 (gift of Victoria Nebeker Coberly, in memory of her son John W. Mudd, and Walter H. and Leonore Annenberg)

© National Gallery, London: 119

The Nelson-Atkins Museum of Art, Kansas City, Missouri: 143 (purchase: Nelson Trust)

Österreichische Galerie Belvedere, Vienna: 48–49

Philadelphia Museum of Art: 58 (Mr and Mrs Carroll S. Tyson, Jr., Collection) © Collection Philippe Piguet: 36; 87; 124 (photo André Arnyvelde)

Phoenix Art Museum: 128 (gift of Mr and Mrs Donald D. Harrington)

Private Collection: 6

© Photo RMN – André Arnyvelde: 127 below

© Photo RMN – Hervé Lewandowski: 16; 24–25; 47; 64–65

Vivian Russell: 157

Scala, Florence: 133

Sotheby's Picture Library: 53; 66–67; 82

© Sterling and Francine Clark Art Institute, Williamstown, Massachusetts, USA: 38

Sunset Publications, Tokyo: 46

© Tate, London 2001: 90–91

Terra Foundation for the Arts, Daniel J. Terra Collection (photographs courtesy of the Terra Museum of American Art, Chicago): 110 (1999.106); 88 & 106–107 (1999.55); 100–101 (1999.127); 92 (1999.18); 95 (1988.22)

Terra Museum of American Art, Chicago (photograph courtesy of the Terra Museum of American Art, Chicago): 43 (gift of Mr Ira Spanierman, c1985.1.6); 103 (gift of Mr Ira Spanierman, c1985.1.25)

Virginia Museum of Fine Arts, Richmond: 121 (the Adolph D. and Wilkins C. Williams Fund). Photo Wen Hwa Ts'ao © Virginia Museum of Fine Arts

Wadsworth Atheneum, Hartford (bequest of Anne Parrish Titzell): 9; 79

AUTHOR'S ACKNOWLEDGMENTS

Many people graced this book with help and encouragement, and I would like to take this opportunity to extend my gratitude. At Frances Lincoln Limited, my special thanks go to Carey Smith, who originated and oversaw the project, to Sue Gladstone for editing the pictures, a task that required persistence and creativity, and to Frances Lincoln, for her gracious support. Thanks as well to Tom Armstrong for his assistance. I owe a deep debt of gratitude to Jinny Johnson for editing the manuscript; her enthusiasm and encouragement were an essential part of this project from beginning to end.

For assistance in my research, I would like to thank the staff of the Terra Museum of American Art in Chicago, especially Shelly Roman Abellera, and Derrick R. Cartwright, the Director of the Musée d'Art Américain in Giverny. I am grateful as well to the staff at the Flaxman Library of the School of the Art Institute of Chicago, with a special nod to Roland Hanson, and to the staff of the library at Columbia College in Chicago, especially Larry Oberc. As always, I appreciate the support of the Newberry Library in Chicago for including me in their community as a Scholar in Residence. A special note of gratitude goes to Gloria Groom, the David and Mary Winton Green Curator in the Department of European Paintings at the Art Institute of Chicago, for her ready help when it was needed.

Throughout this project, my family and friends encouraged me with patience and good humour. My deep gratitude goes to my mother Elinor R. Mancoff, for always being there to listen, and to my father Philip Mancoff, whose love of flowers and admiration for Monet touched my heart long before this project began. I am grateful as well to those friends who buoyed my spirits throughout the project, including Ann M. Brizzolara, Jay Frey, Paula Lupkin, Sarah H. Marggesson, and Andrew J. Walker. A special note of thanks goes to Paul B. Jaskot and Michael Hires, who were always ready and eager to share their insights. Thanks as well to Jinny Johnson and John Porter. Our shared trip to Giverny was a delight; I thank Jinny for taking wonderful photographs and John for scouting out important sites. Finally, I'd like to express my gratitude to Bee Thompson for her hospitality in London. Her garden feels like home to me, and it is to her that I dedicate this book.

Debra N. Mancoff

Chicago, July 2000